3D**MASTERCLASS**

THE
SWORD**MASTER**
IN 3DS MAX AND ZBRUSH

THE ULTIMATE GUIDE TO CREATING A LOW POLY GAME CHARACTER

3DTOTALPUBLISHING

3D**MASTERCLASS**

THE
SWORD**MASTER**
IN 3DS MAX AND ZBRUSH

THE ULTIMATE GUIDE TO CREATING A LOW POLY GAME CHARACTER

CONTENTS

PROJECT**FILES**

To help you follow Gavin Goulden's processes in creating a low poly game character, he has provided some relevant ZBrush sculpt, game assets and Marmoset settings files. So before you read on, please download these files to your desktop.

For all the files that you will need to follow this book, please visit: **www.3dtotalpublishing.com**. Go to the "Resources" section and there you will find information about how to download the files.

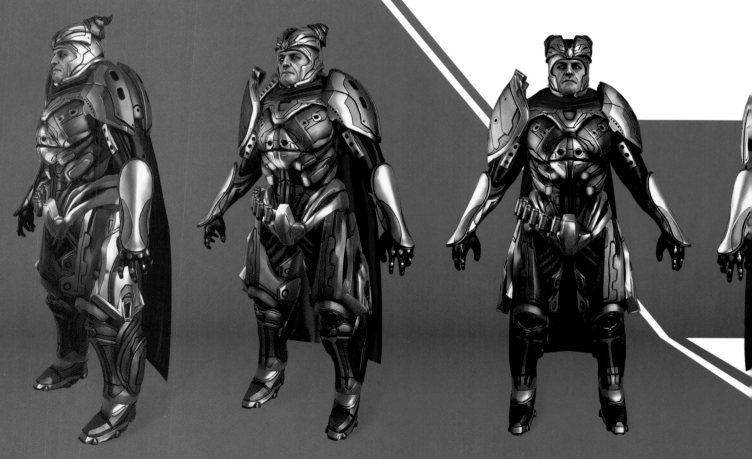

Correspondence: publishing@3dtotal.com

Website: www.3dtotalpublishing.com

First published in the United Kingdom, 2013, by 3DTotal Publishing

Paperback ISBN: 978-0-9568171-7-4

Printing & Binding: Everbest Printing (China)

www.everbest.com

Editor: Jessica Serjent-Tipping

Sub-editor: Jo Hargreaves

Design and Creation: Christopher Perrins

Image Processing and Layout: Matthew Lewis

Visit www.3dtotalpublishing.com for a complete list of available book titles.

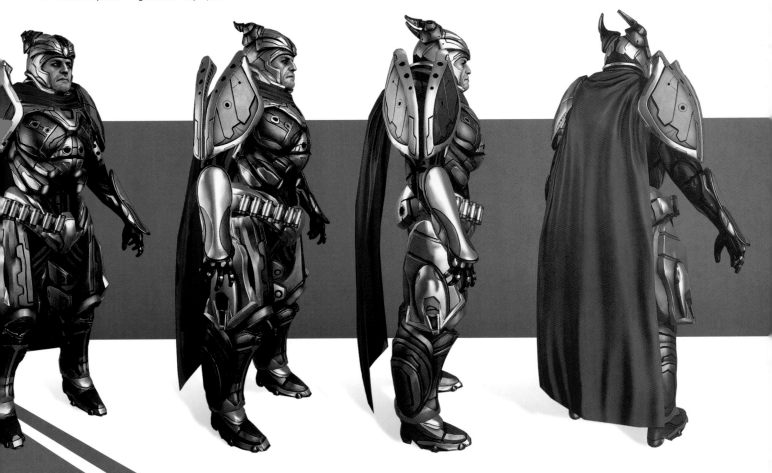

3DMASTERCLASS | THE SWORDMASTER

THESWORDMASTER
INTRODUCTION

Once I was approached to write this book, I instantly saw it as an opportunity to gather my thoughts on a subject that I have specialized in for a number of years, and create a package of information that I hope will guide artists through the process of creating a game resolution character, ready for AAA quality. Drawing on my own personal history, the lessons in this book are the product of years of trial and error from my own experiences working in the games industry as a character artist.

After I was presented with the awesome concept art for the project, which is by Ignacio Bazan Lazcano, I began breaking the character down into valuable lessons in character model creation. The intention of the Swordmaster tutorials is to show the key aspects of my own workflow for creating game characters and presenting them in a way that is easy to understand by artists of all skill levels. All of the lessons within this book are not just standalone points; they can be applied to your current and future projects as well. Once you have completed this tutorial series, you will have a solid understanding of both high and low poly modeling, painting textures for games, the basics of rigging, and how to properly present your work in a digital portfolio.

I have contributed smaller articles before, and have written tutorials that were not as in depth as this book. The Swordmaster has been a challenge, a learning experience, and a huge accomplishment. It was a long road to see this project through to the end, with many months spent editing both the written and artistic content. I hope that it shows, and I hope that you enjoy reading this book as I much as I did writing it.

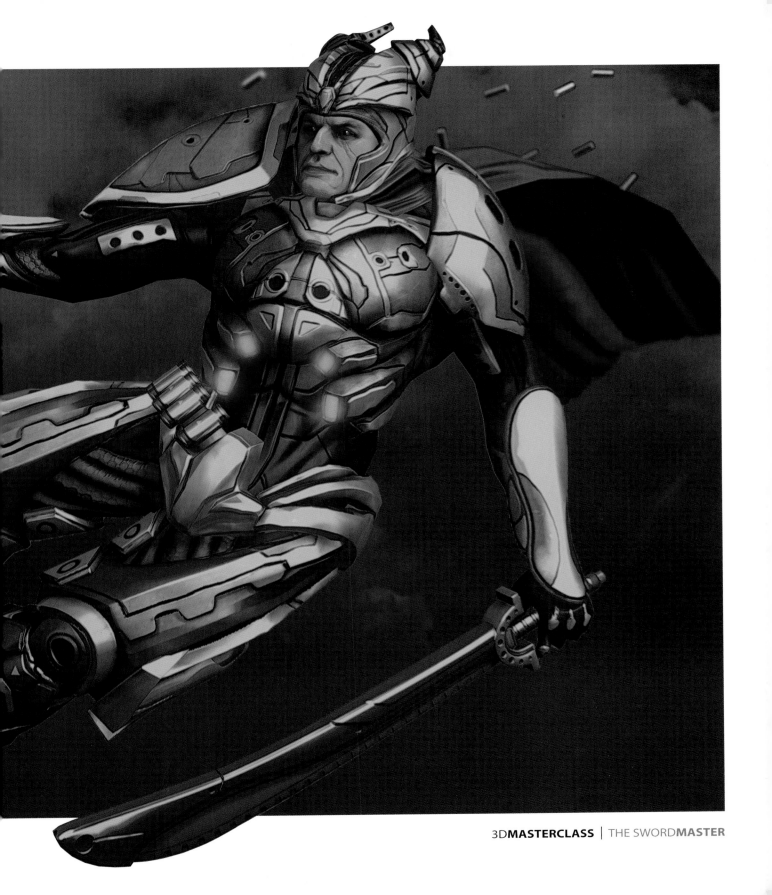

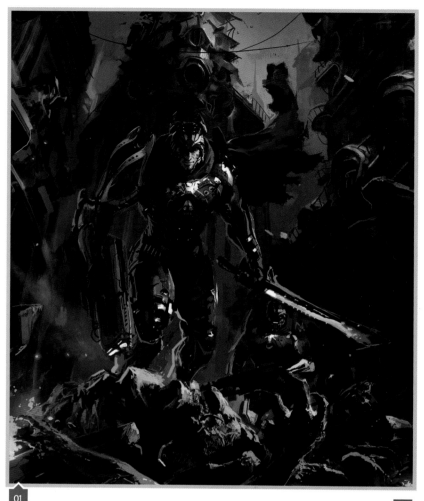

CHAPTER**ONE**
MODELING THE BASE MESH

Introduction

In this portion of the series we are going to cover creating a base mesh model. A base mesh is the model intended for sculpting and ultimately is the beginning of what our high poly model will be. For this project, the base mesh will include organic sections such as the face and body, which will then be sculpted and used as a basis for armor design in future sections. Using this workflow is a great way to increase speed and really get your ideas into 3D quickly, worrying about overall aesthetics first and clean topology second.

Step**01**

We begin by gathering references. In this case concept art has been provided for us in the form of an action pose and a standard model sheet showing the front, side and back of our Swordmaster character. Different projects will require a different level of accuracy; once you become comfortable with your craft it is perfectly fine to model in perspective view or freestyle details. On most commercial projects, there will already be character rigs used within the game, which will require you to build your model to those guidelines. This helps on a wider scale as you can then share animations between characters with similar body types (Fig.01 – 02).

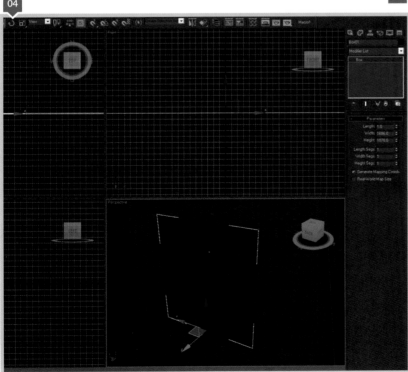

Step02

To begin, I split up the character based on the views that I will need. For me this is just going to be a rough guide to help ensure the accuracy of proportions. When it comes to detailing, I tend to switch to a freestyle workflow. In Photoshop, select the area that includes the front view of the character. Press Ctrl + C to copy the information, open a new document and save it as a new image. Repeat the process for the side view, making sure to take note of the height and width of each image (Fig.03).

Step03

Next, open up 3ds Max and create a box by going to the Create panel and then navigating to Geometry > Standard Primitives. Click and drag in the Perspective viewport to create the box primitive. In the Width and Height rollout menus, enter the dimensions of your front view image. In my case, the image is 1686 x 1878 units (Fig.04).

Step04

The box now needs a material as a perfectly black box makes it very hard to pick out edge details. We also need this material to begin setting up our reference images. Press M on your keyboard; this will bring up the Material Editor. You'll notice a nice collection of blank shader balls. Click on the first shader ball and rename it "Front". This will be the material used to display our front view reference image. Move over the object, right-click and select Convert to Editable Poly from the menu that appears (Fig.05).

Step05

Click on the Diffuse button and then click on Bitmap. This will allow a 2D image to drive the basic color information within your material. Navigate to your front reference image and click OK. Select your front view box and click the Assign Material to Selection icon or, alternatively, click and drag the shader ball onto your model (Fig.06).

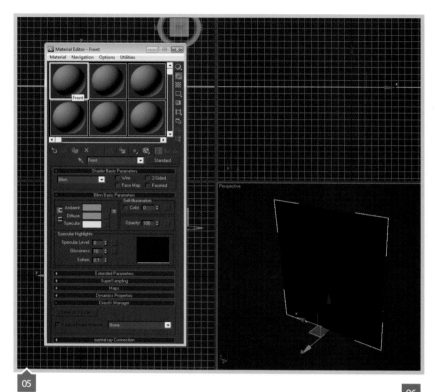

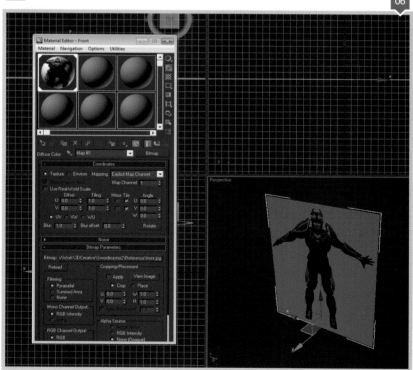

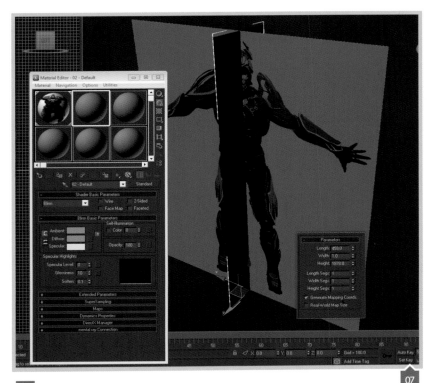

Step06

Create another box and give it the dimensions of your side view image in the Length and Height coordinates. To make sure that both boxes align perfectly, you can select each box and enter the sizes into the XYZ coordinates at the bottom of the screen (Fig.07).

Step07

Create a new material in the Material Editor and enter the name "Side". This will help keep things organized as you move along in the project or if you need to change anything. Apply this material to the new object you created (Fig.08).

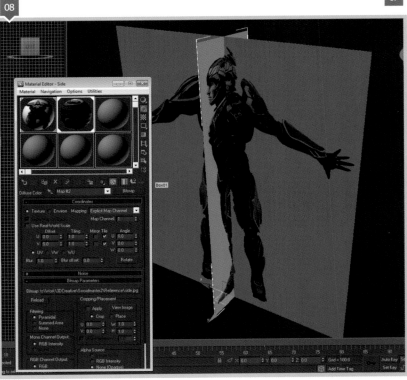

Step08

Next create a new box and enter Edge mode by pressing 2. Split the box down the middle by selecting a ring of edges in the XZ plane and pressing Connect in the Edit Edges panel. By simply clicking the Connect button, it will use whatever value was previously entered. By default the value is 1. By clicking the details box next to Connect, an options menu appears that allows you to adjust this value. This rule can be applied for most functions in Max (Fig.09).

Step09

Enter Face mode by pressing 4 and delete all of the faces of the box except for the left side on the XZ plane. This grid will be used as the basis for the rest of our character's face. Enter Object mode and move this new grid so that the bottom right corner roughly lines up with the mid-point between both of the character's eyes (Fig.10 – 11).

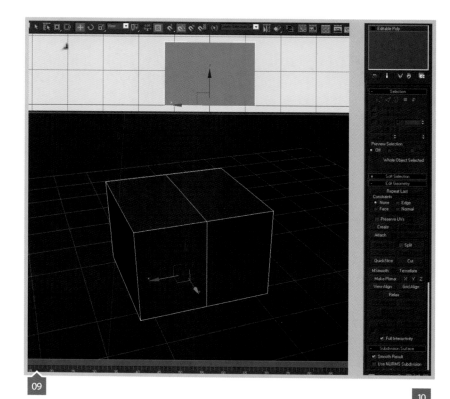

09

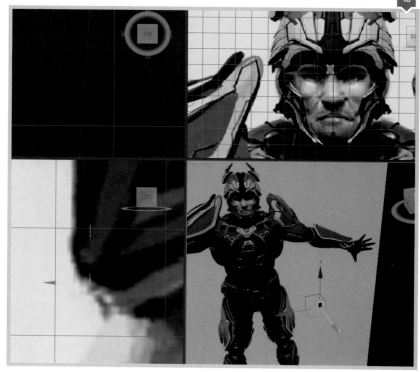

10

11

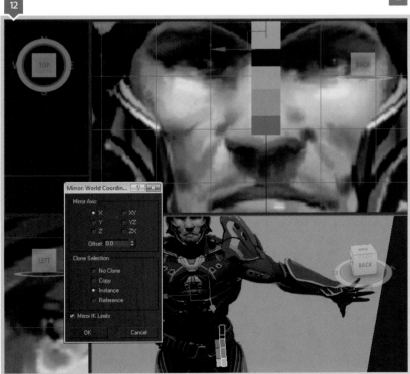

12

Step 10

The main modeling technique I use is edge extrusion. This means that rather than taking a primitive and cutting away at it until it resembles the shape needed, I duplicate edges along paths and fill in the remaining areas. After some practice, I find that this technique allows me to quickly block out forms, requires less clean-up work and gives more control over edge flow. This style of modeling also requires you to constantly check your model from all angles. Since it is mostly used in the perspective view, it is easy to move away from the concept's proportions, so be sure to check your work often.

Begin by selecting the bottom-most edge, holding Shift and moving the edge down in the Z axis. This essentially creates a new face and you immediately begin controlling the connecting edges. Repeat this process until you reach the tip of the nose, making the faces more or less as squares for better subdividing during sculpting.

At this point I also begin working with symmetry, which can be accomplished in various ways. I prefer to instance the model, mirrored on the X axis. This doesn't require us to depend on a modifier and allows us to make duplicates of the original object that will carry changes over to the new objects. With the object selected, navigate to the top of your screen and click the Mirror icon. When the options menu appears, select Instance and the X axis. An instance means the new object will copy future changes made to the original object (Fig.12).

Step11

From here on out, we will basically be using the same technique to mark key landmarks of our base mesh. The key to a good base mesh is evenly distributed polygons, meaning that all of the faces are roughly square and that no area is denser than the others. However, if the model is broken into different sections (e.g., a head and a body) the head could be denser than the body depending on what you need. Another important thing to keep in mind is that ZBrush does not play kindly with triangles, so the model should be mostly made of quads with triangles reserved for areas that won't need sculpting attention.

Continue to extrude edges to mark the extreme angles of the character's face, outlining the brow, bridge of the nose and the chin. Try not to go into too much detail when creating the base mesh as a large portion of the high resolution work will be done in ZBrush. Also, the more dense a mesh is the more complicated it becomes to work with as there are more vertices to manage (Fig.13).

Step12

Next, using the front reference image as a guide, begin marking the character's cheekbones by connecting the outer brow to the top corner of the lip. This mimics the muscles underneath the skin that allow our faces to squash and stretch during extreme poses. Begin to define the shape of the lips and give depth to the eye sockets by defining the brow more (Fig.14).

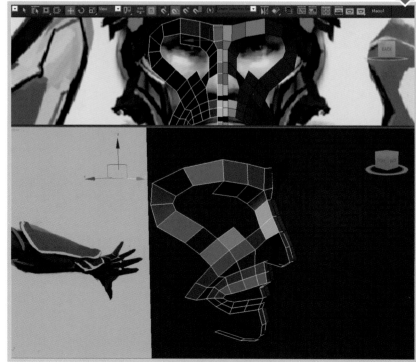

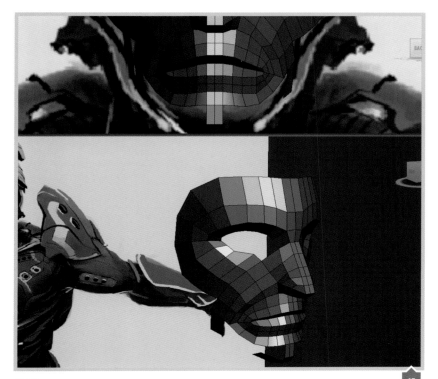

Step 13

Now you can begin to fill out the face by defining the eye sockets more by extruding edges inward to give them some depth. You can also fill in the lips by connecting the top lip edges and bottom lip edges and filling in the nose. Don't bother detailing the nostrils as you can add these details in ZBrush (Fig.15).

Step 14

With the brow and cheeks defined, begin filling in the eye sockets by grabbing the boundary of edges and extruding them inwards, connecting the top and bottom edges together with a connecting edge dividing them. This will help place our eyes when we sculpt, and by using simple geometry it allows us to experiment with different eye shapes and details without everything becoming too messy (Fig.16).

Step 15

If you find these edges too sharp and you would like to soften the area, select the vertices in that area and in the Modify panel, scroll to Relax. This will add a Relax modifier that averages out the position of the vertices without adding any geometry, which is good for smoothing out tight areas like eyes and mouth corners. Once this modifier is added you can increase the intensity, with 0 being your original model and 100 being fully relaxed, and the amount of iterations, which more or less repeats the function. So a Relax modifier of 0.5 with 2 iterations is the same as a modifier with the strength of 1 with 1 iteration. Once you are done with the modifier, right-click over it in the stack and click Collapse To. This will bake any changes down to your model and allow you to continue modeling (Fig.17).

Step 16

The last step you need to take is to fill out the character's cheeks and jaw, connecting the edges of the chin to the ring of edges creating the forehead. For this character you just need to create the face as the rest of the head will be covered by armor. However, using this same technique you can easily see how the shape of the cranium could be completed (Fig.18).

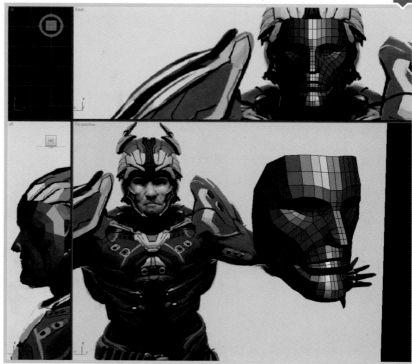

19

Step17

With half of the face complete, you need to connect both sides. In the Modify panel, right-click Editable Poly and select Make Unique. This causes the object to no longer affect its instance. It also allows us to attach one model to the other (Fig.19).

Step18

With either side of the model selected, scroll down in the modifier and select Attach. This will change your cursor to a crosshair type object, which means that Attach mode is active. This means any object that you select will become part of your original model. Select the other side of your character's head and right-click to end the operation (Fig.20).

20
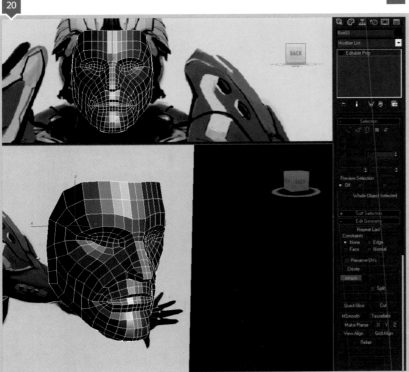

Step**19**

After you attach the halves of the face together, there will still be a seam running down the middle. To fix this select the boundary edges, and click the Weld action in the Modify panel. If the edges do not weld together right away, you can open the options menu and raise the Tolerance amount. This will cause edges or vertices within that distance to become fused together (Fig.21).

Step**20**

With the head complete, it is time to move on to the character's body. Here is where you can start to stray from the model sheet and I believe this process comes down to personal preference and what your project requires. A rig pose may be predefined, which restricts you to modeling your character a certain way, so you may need to model to a rig rather than rig to a model. Modeling a character in the standard T pose – that is with the character's arms raised to be parallel with the floor – can cause stress on the mesh and end up giving your character a box torso when the arms are lowered, but it is also incredibly easy to work with as you are dealing with straight edges. Modeling at a perfect 45 degree angle can be easier to rig, but can be a touch awkward to look at. When not dealing with one of these standardized rigs, I like to relax the arms a bit from a 45 degree pose, basically dropping the hands inward a touch with the back of the hands facing outwards. To me, this leaves the character looking natural and takes away any stiffness from the usual poses.

With the granted freedom of a personal project, I will sometimes change my character's base pose as I work. Essentially, I block out a more standard pose – like the relaxed 45 degree pose – and go from there, maybe bending the spine more, changing the character's posture to reflect attitude, bending the arms, etc. Really, if there are no limits, it all comes down to what works best for you and what is the easiest way to sculpt (Fig.22).

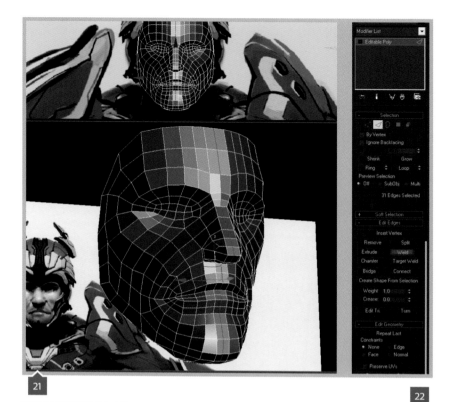

21

22

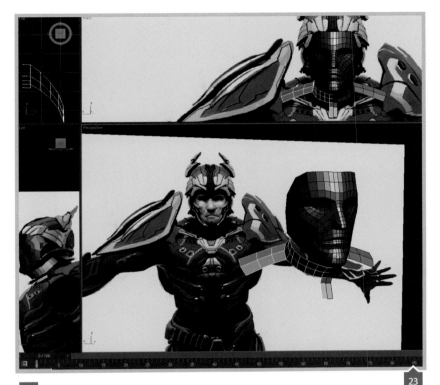

Step21

Create a box for the neck using the same technique, extruding edges from one edge to follow the length of the neck from the chin to clavicle and working from there horizontally to create the rough shape of the neck. To mark the area, rough out the general length of the trapezius muscle; this helps give an idea of where the deltoids will begin.

The general idea here is that you will be creating a character's under-armor, which will then be sculpted as a basis for the real armor pieces and organic sections in between (Fig.23).

Step22

Extrude edges from the base of the clavicle all the way down to the waistline, adding a slight indication of where the chest will protrude. Using the side reference shot as a guide, begin to block in a loop for the entire waist. This quickly helps to show how wide the character will be and will also act as an anchor for connecting edges to the chest and legs (Fig.24).

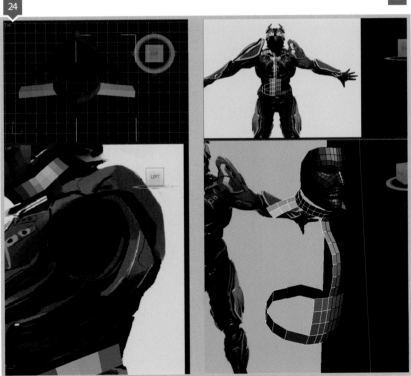

Step**23**

Next begin widening out the chest and stomach. For the most part, the stomach should be practically cylindrical with loops running horizontally the whole way around. The edges making up the bottom of the pectoral muscles, however, will carry through into the bottom of the deltoids and around the back into the spine. This helps define the armpit area and the mass for the shoulders that is created when the arms are raised or lowered (Fig.25).

Step**24**

From here define the mass of the deltoids. I like to create a loop that circles the upper portion and loops around the arm. This comes mainly from an animation standpoint that has carried over to my base model creation technique, but it also helps to define the valley where the clavicle, trap and deltoid meet (Fig.26).

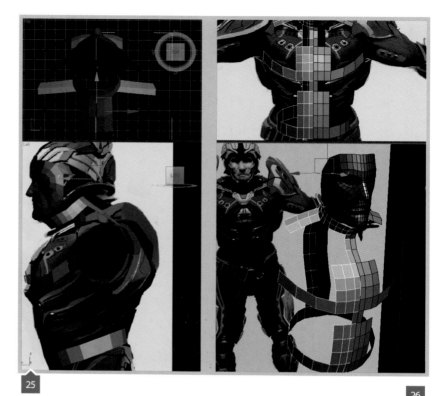

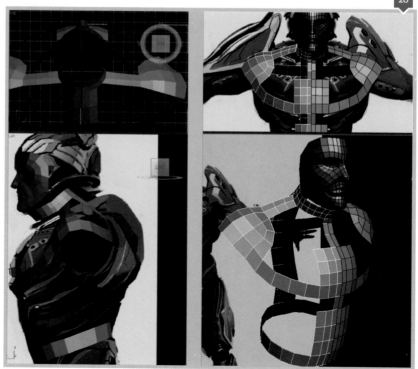

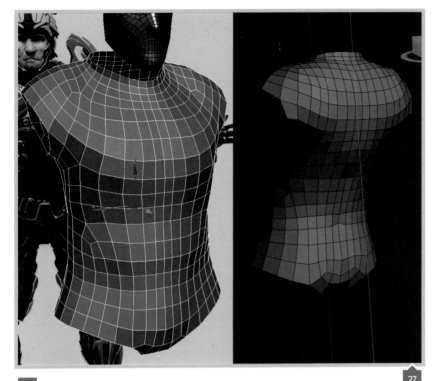

Step 25

To complete the body, the rest of the work is really just filling out these major points that we have defined with clean topology, keeping the mesh equally dense and composed of four-sided polygons. Much like the shoulders you should define the hips with a loop that will circle the legs. I also like to continue the edge flow of the shoulders across the entire back (Fig.27).

Step 26

When it comes to hands, treat them as if they are an entirely new object. Rather than working from a character's wrist to the fingertips, begin building a finger. The first step is to simply make a cylinder and delete the end caps. Add a few edge loops around the finger to retain mesh fidelity when it becomes subdivided. This initial piece can be as complex as you need it to be – whatever works best for your workflow. Some artists are fine with a four-sided finger; I like to go a little heavier and use around eight edges. The reason for this is that I want the fingers to retain their shape when I'm sculpting, without the need to build the shapes back up or use creasing techniques on specific areas before sculpting. In my opinion it's just easier this way (Fig.28).

Step**27**

From here use the edge extrusion method to begin building out the rest of the finger. Rather than modeling the finger straight, try to give it a slight curve. This will give the finger a more natural feel and help you visualize the bends. For the knuckles I cut into the faces that would need a protrusion and push the center loop out just a touch. Changing the silhouette ever so slightly in this way helps get rid of the "sausage fingers" look (Fig.29).

Put fingernails in your fingers by selecting the faces near the tip of the finger and in-setting them with a bevel. After this grab the edges closest to the nail base and overlap the nail geometry, creating the mass near the cuticle. I usually stay away from this type of detail in a base mesh, but it can be easily flattened out in ZBrush.

Step**28**

Next take the finger you created and duplicate it three times. In general try to keep the finger that you created as the middle or ring finger, and then adjust the different fingers' lengths. You'll notice that the fingers on a human hand are not the same length. In Fig.30 you can see the right hand, so the fingers will increase in length from the pinky to the middle finger with the index finger's tip lining up with the last knuckle on the middle finger.

29

30

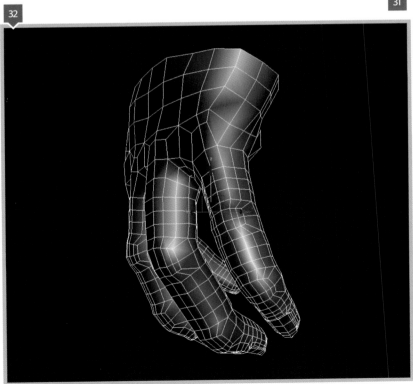

Step 29

After this fan out the fingers as if they are stretching apart by rotating each one, much like the previous step. Also stagger the fingers to offset the knuckle placement. You'll notice that when you make a fist, your knuckles are not perfectly in line. Connect the base of the fingers to create the thin webbing that stretches in between fingers near the knuckles. To give the hand a little more life, bend the fingers slightly at the knuckles, as if there is a little tension. This helps set landmarks on the fingers for sculpting and makes the fingers look less boring. Add in more loops for the webbing near the knuckles to retain the model's shape when it becomes subdivided.

Next you can begin building the hand by making the knuckles and connecting them to the fingers. Try not to go too overboard here and try to fan out the border of the finger at the knuckle, and join them with the webbing geometry created earlier. This creates a loop around the finger at the knuckle that helps isolate each finger and defines the knuckle protrusion. If this hand were to be weighted in a game scenario, the palm is generally weighted to one bone with three bones for each finger. So try to model with that in mind, leaving a defined edge that would be dominated by the hand bone with enough geometry between the hand and first knuckle on the finger to retain the shape when bending during animations (Fig.31).

Step 30

Using the edge extrusion method, begin to build out the palm and back of the hand. Follow the same rules as you did for the fingers. You don't want it perfectly flat and straight. Try to show the meat of the hands by forming pads on the outer edges with a dip in the center where it is mostly flesh on bone. For the back of the hand, you want it to be rather flat (as in not defining veins, knuckles and the metacarpals), but to curve down towards the palm slightly on the inner and outer edges (Fig.32).

Step31

From here, continue extruding edges to build out the back of the hand to the wrist. On the palm try to begin the edge loops for the thumb as soon as you can. The thumb will affect a large part of the hand as it has a wide range of motion that requires it to collapse and compress on the palm and back of the hand. Defining the flesh that creates the base of the thumb, reaching into the center of the palm, can be greatly beneficial for this deformation. Try to keep the same edge that would run down the center of the fingers, as if it were cutting the finger in half, into the thumb. This helps define the webbing and muscles between the index finger and thumb, which will do most of the stretching and squashing as the hand spreads apart or makes a fist.

Next create the thumb. Try to make the base of the thumb have the same amount of edges as the fingers so that you can duplicate a finger tip, move it into place and easily connect it to the rest of the hand. By duplicating the faces of a fingertip you can modify it quickly to create the broader tip of the thumb, as well as the more bulky knuckle. From here, connect the thumb's tip to the hand by bridging edges. Divide the thumb with a few edge loops, creating a taper from the hand to the knuckle (Fig.33).

Step32

Finally connect the hand to the rest of the arm. The key part to keep in mind is how the hand tapers into the wrist and how the heel of the palm drops down from the inner forearm. Next extrude edges out of the wrist and continue to the elbow area, usually defining the subtle twist and bulk of the muscles that the forearm would create (Fig.34).

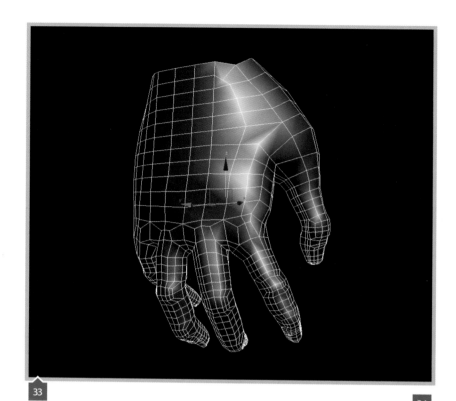

33

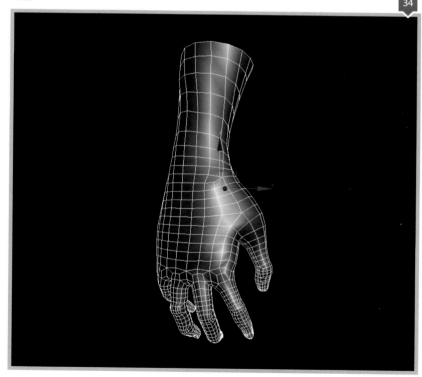

34

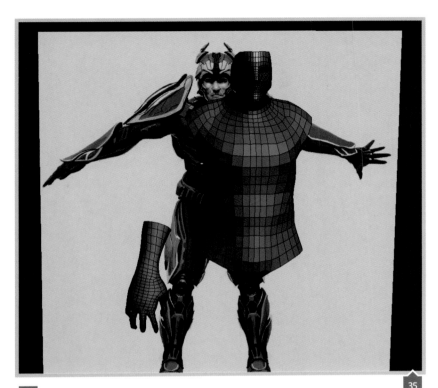

Step33

This is a good time to place the hand roughly where it should sit in a relaxed position. For the most part the character's elbow should touch the bottom of the ribcage and the fingertips should rest near the middle of the upper leg when fully relaxed. This helps you visualize the character's proportions quickly and will allow you to easily piece together the rest of the upper body (Fig.35).

Step34

Much as you did with the face and body, mirroring the hand as an instance gives a nice quick preview (Fig.36).

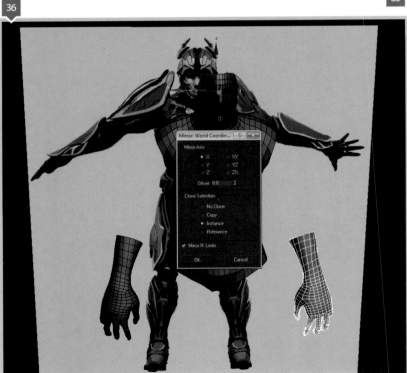

Step**35**

Create a quick approximation model of where the character's feet will go. This doesn't have to be perfect or detailed, as in this case we are going to create the boot as a high poly when we do the sculpting. This is simply a way to make the character not look goofy as a character with no feet can really trick the eye into thinking that the proportions are off (Fig.37).

Step**36**

Now the process of connecting the arm to the body begins. Keep an eye on the boundary edges of each piece (the forearm and the arm hole) as you want them to be even. Now is a good time to add or collapse edges as you see fit. You can select a boundary by pressing 3 on your keyboard. This will select any open edges. In the case of my model I need to add edges to my torso (Fig.38).

37

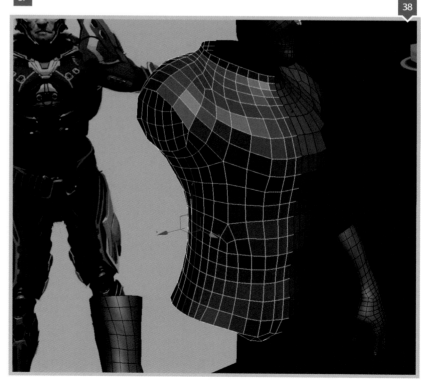

38

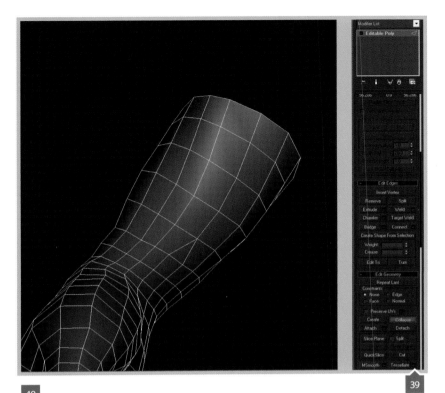

39

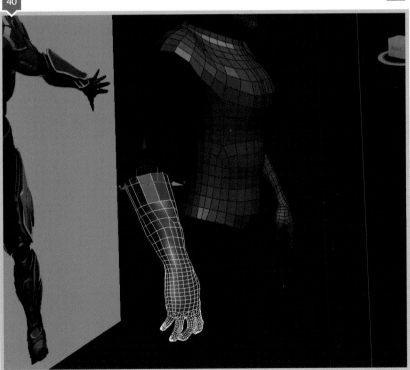

40

Step37

To make the amount of edges equal for the arm and torso you need to collapse a few edges around the wrist. Once the edges are collapsed, this will create an undesirable triangle that can be corrected by connecting two triangles with a horizontal edge that runs around the wrist (Fig.39).

Step38

Next extrude the boundary edge of the forearm to roughly where the character's elbow will be, checking all angles of the extrusion to make sure that there is no awkward bend in the arm (Fig.40).

Step**39**

Extrude an outer edge to meet the tip of the deltoid area. The idea here is to block out the length of the upper arm and elbow. I find that it is easier to keep the base mesh clean if you do not factor the twist of the arm into the geometry. The twist of the muscles can be shown in the sculpt later and propagated into the low poly much later down the line (Fig.41).

Step**40**

The next step is to attach the body to the arm. First select the body and navigate to Attach in the Modify panel. Select the arm and right-click to exit out of the Attach function. This will add the arm geometry to the body and will allow you to properly connect the two. As you can see, this will also carry the change over to the instanced half of the body (Fig.42).

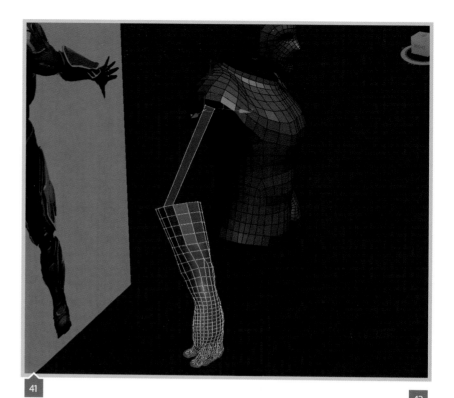

41

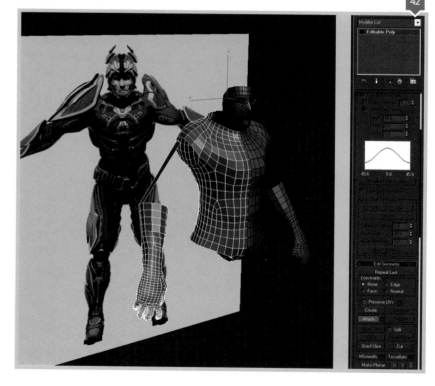

42

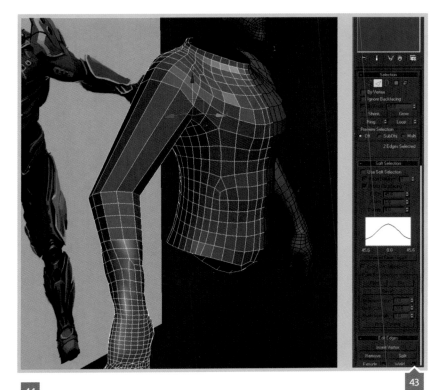

Step41

Next use Weld to connect the recently created edge to the nearest edge on the torso (Fig.43).

Step42

Since the arm and torso have the same amount of edges on the boundary, it is easy and simple to create the rest of the upper arm by selecting the Bridge function to connect them with a new polygon. Continue this process around the entire arm (Fig.44).

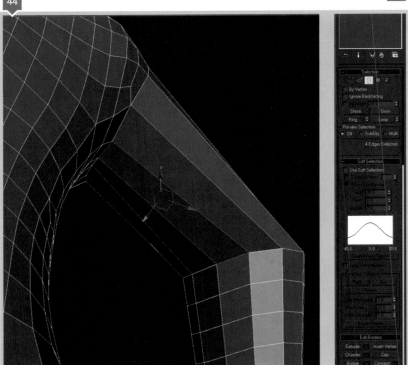

Step**43**

To soften up the elbow area and to avoid any pinching when the model is subdivided in ZBrush, select the loop of vertices that make up the actual bend in the arm.

Next expand your vertex selection by clicking Grow while in Vertex mode. This will add adjacent vertices to your selection around the arm. With all of the vertices selected in the elbow region, apply a Relax modifier, which will average out the vertices around the elbow and give us a smoother transition (Fig.45).

Step**44**

Now move onto the legs. For this character (as mentioned earlier) we're just going to focus on the actual legs and not the feet, as this character's design shows that almost everything from the knee down is covered with armor plating, which will be covered in the high poly modeling section. Grab a few edges on the hips and extrude down to where the knees would roughly be. From here, begin to build a loop around the leg, using the front and side reference shots as a guide (Fig.46).

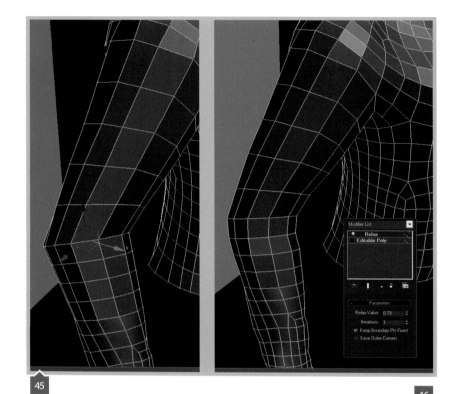

45

46

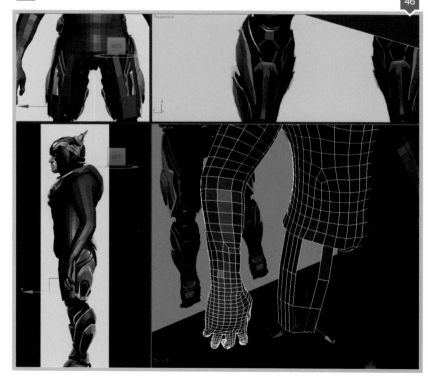

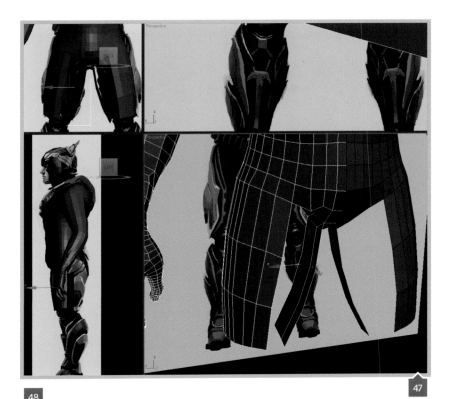

47

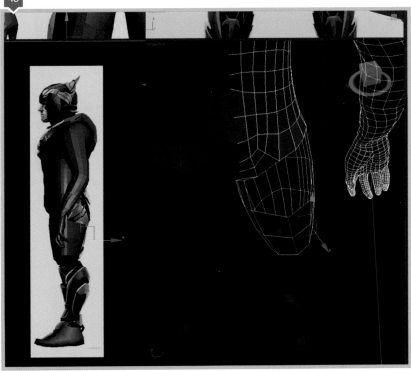

48

Step 45

Do the same for the inner thigh, extruding an edge from the crotch down to roughly the same area as the opposite side, adding the same amount of horizontal edges so that both sides can be easily connected (Fig.47).

Step 46

From here, use the Bridge function to connect both sides of the leg that you have created. Also add a few vertical edges to pull out and add some bulk to the upper leg to roughly match the side reference (Fig.48).

Step**47**

Now add vertical edges running down the front and back of the leg to match the amount of boundary edges on the hips. This is basically the same process we followed for connecting the arm, just that the amount of edges for the body shouldn't be changed (Fig.49).

Step**48**

Roughly block out the shin area, extruding edges from the upper leg/knee area. I suggest extruding the edge fully down to the ankle, and adding horizontal edges to round out the shape and even out the polygon distribution. Again this area is mostly just to assist your eye in seeing the character's proportions and will be modified heavily in future steps (Fig.50).

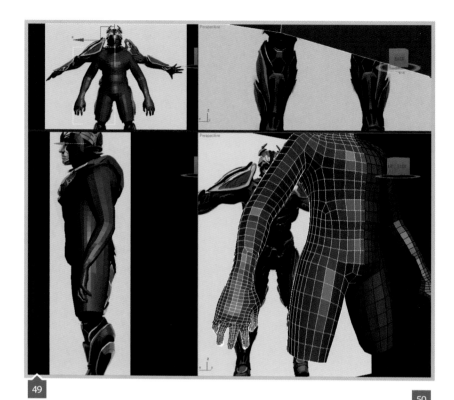

49

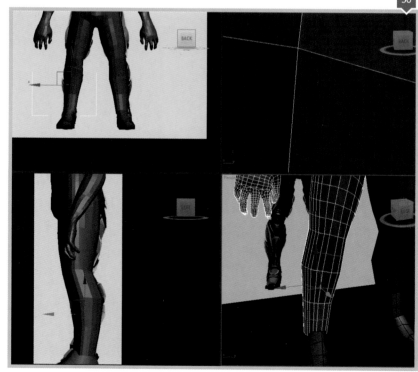

50

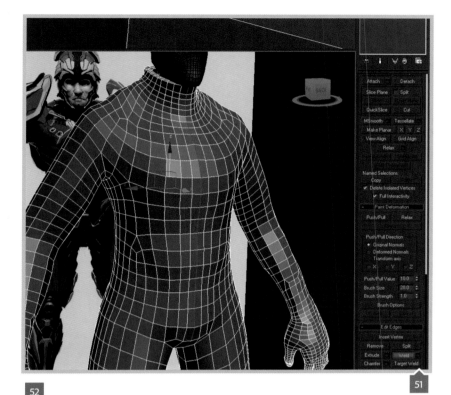

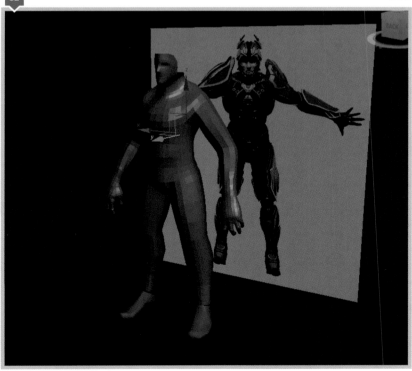

Step**49**

Just like you did with the face, make one half of the body unique and attach it to the other half. Grab the center edges and weld them together to create one consecutive mesh. Check your mesh by entering Boundary mode (3) and pressing Ctrl + A to select all of the open edges of your model. The only edges highlighted should be the neck and the holes near the ankle. If not, make sure that you weld these other edges together before moving on as it could cause problems when subdividing in ZBrush (Fig.51).

Step**50**

This completes our base mesh modeling section. From here, we will export the model to be used in ZBrush where we will quickly sculpt a roughly armored character, build these armor pieces more cleanly in 3ds Max and move on to polishing our sculpt (Fig.52).

Sidebar**Tip**: Quick and Dirty Base Meshes

Once you get comfortable with sculpting in ZBrush, you can use the DynaMesh tool to help block out models quickly from primitives, without causing too much distortion. Designed specifically for more medium range sculpting and block-in modeling, DynaMesh essentially uses a primitive to begin with (sphere, cube, cylinder, etc.,) or you can create your own custom shape. Once your original model is put into DynaMesh mode, you can use any of the tools you normally would within ZBrush for regular sculpting. When your mesh becomes too distorted to work with, simply hold Ctrl and drag on any open area in the ZBrush document. ZBrush will then automatically retopologize your model – without adding any geometry – so that you can continue working efficiently.

Once your work in DynaMesh is done, you can disable the mode and begin retopologizing the model in ZBrush or an external 3D program.

01

CHAPTER**TWO**
CREATING A HIGH POLY MODEL

Introduction

In this portion of the series we are going to dive into the detailing phase of our model. We'll be creating a sketch sculpt in ZBrush, hard surface modeling, detailing in ZBrush, organic sculpting and even covering the creation of our character's accessories: his trusty sword and gun.

Step**01**

With our model exported from 3ds Max as an OBJ, we can simply import it into ZBrush by navigating to Tool > Import and selecting the face base mesh. You can also use Subtool Master, as I will later on, to import a massive amount of models all at once (Fig.01).

Once the model is imported into ZBrush, it won't actually be drawn in 3D space. You will need to click and drag the model on to the canvas and then enable Edit. This allows you to alter the model further; otherwise it will simply be a 2D image on a canvas (Fig.02).

Step**02**

I also have a few custom settings in my ZBrush. I use the default layout, for the most part, and have a set of alphas and MatCaps that I use on a regular basis, which are placed into ZBrush's start up folder. This is just to save me from having to load the same material

02

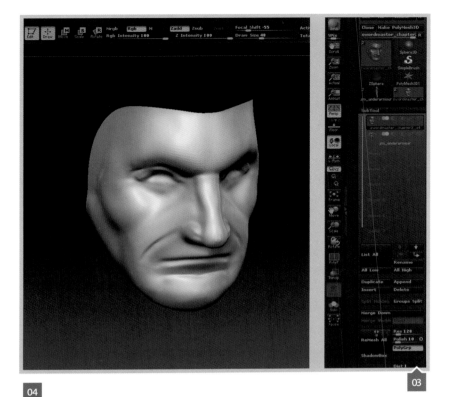

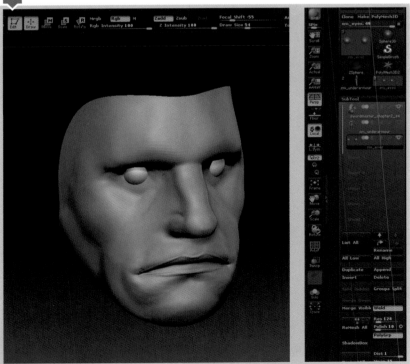

every time. I also have the brushes I use set to hotkeys from 1-6. These can be set by opening the Brush panel, pressing Alt + Ctrl and clicking on a brush icon. For example, I have Standard set to 1, Flatten set to 2, Pinch set to 3, Clay Tubes set to 4, Move set to 5 and Stitch set to 6. Generally, any brush I use is set to Add, using Alt to activate the reverse option, such as Subtract.

Step03

After dividing the mesh a few times by pressing Ctrl + D (you can also manually add divisions in the Tool menu) I begin roughing out the facial features using the Clay Tubes brush. I generally sculpt in symmetry by pressing X. If you navigate to Transform you'll be able to set the axis, or enable multiple axes, to be affected by symmetry. By default this is set to X. At this stage I'm not concerned about details; the goal here is to block in low frequency form information that can be read from far away (Fig.03).

Step04

Next I bring in a set of eyeballs to help keep that area crisp. This is simply two spheres that are mirrored on the X axis. Bring them in by first appending a dummy tool in the Subtool panel, then manually importing the OBJ via the Tool menu. I like to keep these as separate models within ZBrush to keep the sharp line of the eyelids intact against the eyeball. As I'll be altering that area quite a bit it's nice to have the eyes just retain their shape. Plus, it acts as a nice guide for eyelid volume and shape.

Here I begin refining the shapes more by bringing in sharper details, like the lip edges, with a Standard brush (Fig.04).

Step**05**

More refining of big shapes here with a Standard brush. I tend to over-sculpt areas and tone them down during the polishing stages; this can specifically be seen in the eye and mouth corner areas. If you sculpt too much, you can easily smooth out the area by holding down Shift and brushing over the trouble area (Fig.05).

Step**06**

Define tighter details, but still keep it at a low frequency level and avoid going overboard with wrinkles and surface details. Then begin refining the eye area more and sharpen up the nasal folds (Fig.06).

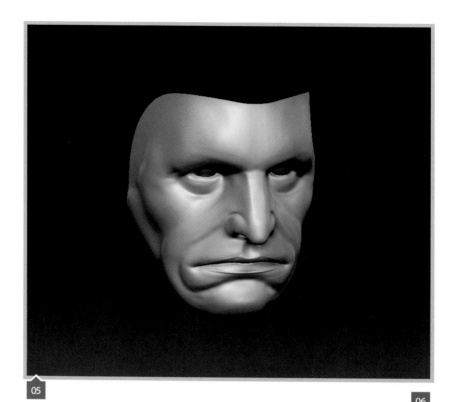

05

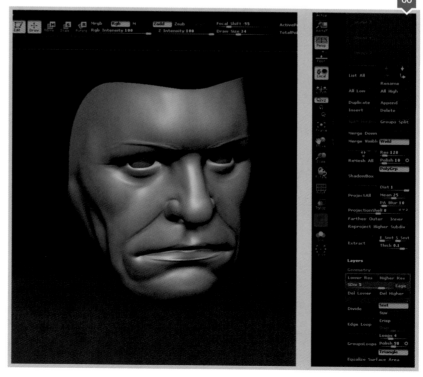

06

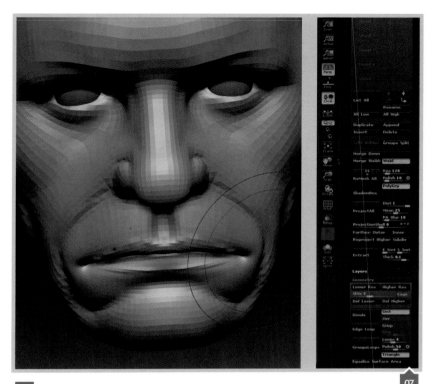

Step07

The mouth is a touch too wide for the character's face. Generally the corners of the mouth line up with the pupil of the eye. So let's drop the subdivision levels to easily alter a larger space. This can be done by simply pressing Shift + D – do this and you'll see your model become lower resolution. With the Move brush selected (not the Move Transpose tool), bring the mouth width in (Fig.07).

Step08

Now move into higher frequency detail – nothing as fine as skin pores, but getting finer details like working the edge of the lips and the flesh of the cheeks (Fig.08).

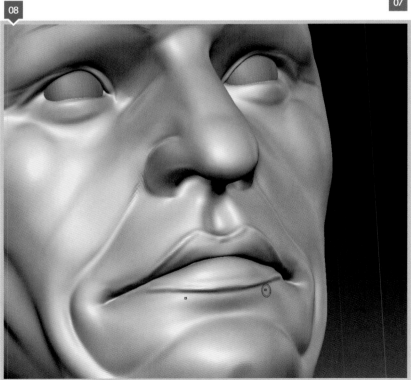

Step**09**

I find it really helps to sell an organic piece, especially a human face, by contrasting hard edges against an otherwise soft object. For example, in this step I've flattened the cheekbones, the eyelids and the bridge of the nose by using the Flatten brush. This helps the details in the face to really pop out by avoiding having all the features form one continuous "blob". Unless you're going for a very stylized look to your character, I would keep this sort of detail to areas that would have bones closer to the skin. Meaty areas, like the chin or nasal fold, may look odd if they are given a sharp treatment, especially when deforming during animations as you will be stretching and squashing a surface that looks stiff (Fig.09).

Step**10**

Add sharper edges at a lower level at the tip of the nose and the edge of the lips. Here, also add slight surface variations with a Standard brush at low intensity. This helps during lighting to show that the skin isn't a perfectly smooth surface. Adding slight depressions, like on the chin and forehead, also shows where skin can bunch up and compress without baking too much expression in a sculpt that's intended to be fairly neutral (Fig.10).

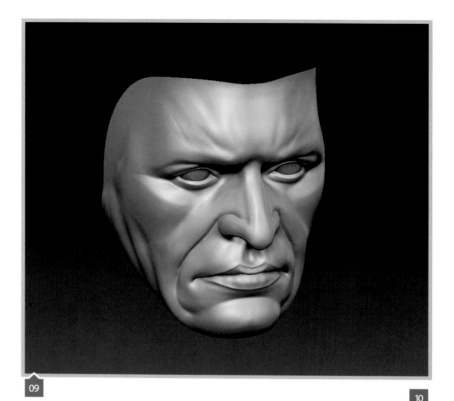

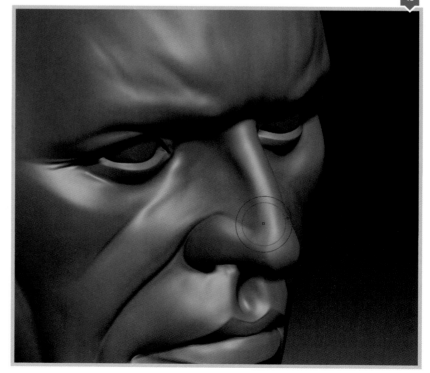

Step 11

To help define the nostrils better, drop the subdivision levels down and move the tip of the nose inward to give the nose a natural flare. Also push the nostrils themselves in using a Standard brush (Fig.11).

Step 12

Now we finally get into the finer details of the skin. Try not to go overboard with this as it can make a character look older than intended, and can make a normal map bake look muddy. There is only so much detail that can be translated in a normal map as it is all per pixel and dependent on your texture's resolution. Lots of pores and wrinkles can all blend together during texture baking and cause the final output to look lower resolution than it actually is. So, for the most part, I like to keep my models clean and isolate detail areas.

I have a few skin pore brushes that I use for character skin. These have been made from a more or less black texture with white dots scattered about. Using the Clay Tubes brush at a very low intensity, paint a few strokes over the peak areas of the skin, like the cheekbones and highest area of the cheeks. Also lightly define the eyebrows with a Standard brush, focusing on a few clumps of hair and being sure not to go overboard with the depth (Fig.12).

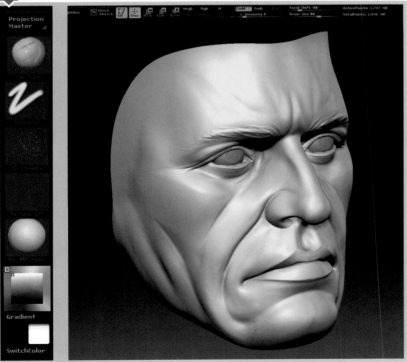

Step**13**

Next, add stubble by following the same steps just in Add mode and targeting the beard area. Again, be sure not to go overboard here as the end result can end up looking more like facial scaring than a five o'clock shadow. You can also add small details to help throw the symmetry of the face off, such as moles and bumps in the skin (Fig.13).

Step**14**

Here you can see the finer details I've added, such as minor scars, blemishes and wrinkles from aging (Fig.14).

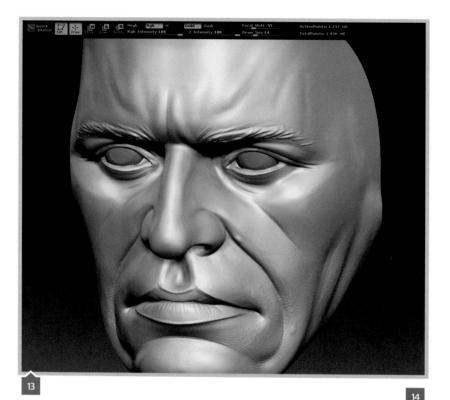

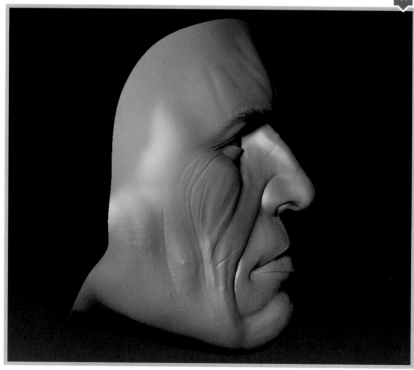

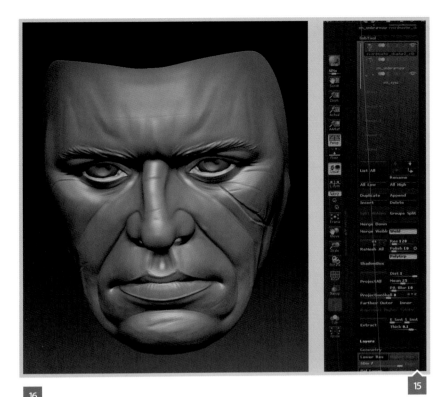

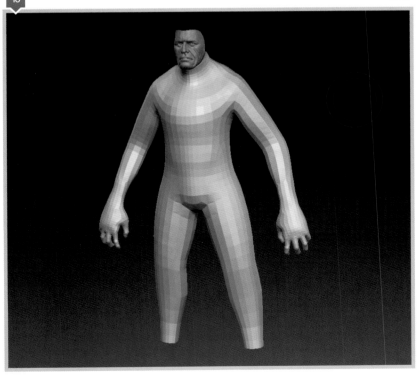

Step 15

There is a detail in the mood concept painting for this character that I had originally thought was a battle scar. I thought this would be a cool touch for the character to show that he's fought before and lived to tell the tale. So, using a Standard brush, let's cut into the skin then flatten the edges to make the cut not as sharp, to mimic skin healing in real life. Also add smaller scars coming off of this main cut to show where skin would have healed awkwardly (Fig.15).

Step 16

Just like the eyeballs, import the under-armor base mesh as a subtool of the face sculpt. In the coming steps, we'll be sculpting out an armor design, practically sketching out the armor in 3D space. Once this is complete, we will build hard surface armor chunks around this sculpt, only to bring them back into ZBrush for surface detailing. I find that this method provides a quick way to prototype ideas or work out complex shapes, and is much more forgiving than traditional modeling techniques (Fig.16).

Step**17**

Much like the beginning stages of the face, start blocking in the chest armor pieces and the connecting armor chunks that guard the sternum and clavicle. The main priority is to just rough out the form of the armor plates indicated in the concept drawing. There is no reason to worry about how smooth the surfaces are as we will be crossing that bridge when we build the armor plates for real (Fig.17).

Step**18**

At this stage, the arms are looking a touch too long, which can easily be fixed with the Transpose tool. First mask out the non-offending areas by holding down Ctrl, which activates the Masking tool, and then paint over the body. Holding Ctrl and clicking on the model will blur the mask. At the top of the screen, clicking Move, Scale or Rotate will activate the Transpose tool.

In this case, let's use a mixture of Move then Rotate. First, click the root of the deformation and then the Effector, much like a bone for animations. After this has been set, move the area up by clicking the middle circle and dragging it up some. Do the same in Rotate mode to correct the orientation of the arm (Fig.18).

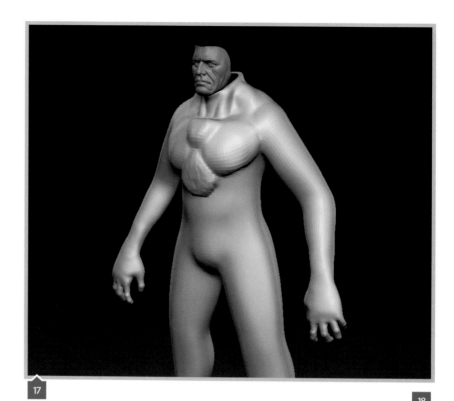

17

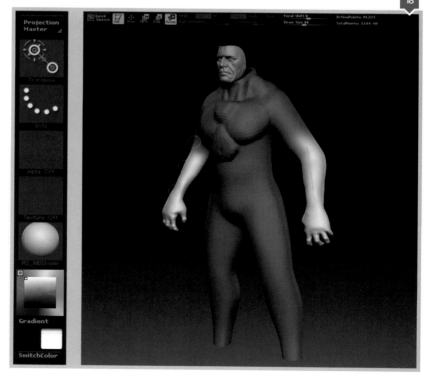

18

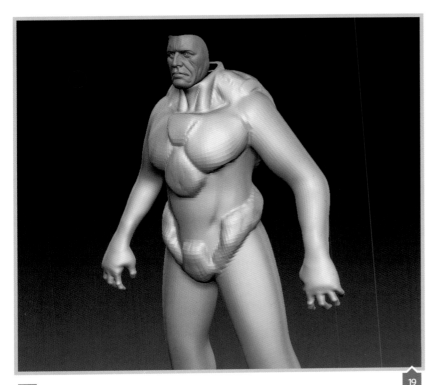

Step 19

After this, begin blocking in the pelvis armor pieces with the Clay Tubes brush. I find marking out the two extremes of the torso helps visualize where the limits of the midsection will be (Fig.19).

Step 20

Now start blocking in the midsection/rib plates as well as the muscle definition for the arms and hands. You can also run a Flatten brush over some of the edges, especially around the pelvis, to get rid of the blobby look (Fig.20).

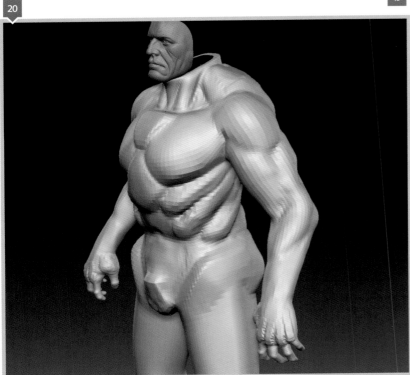

Step**21**

Now we're going to move onto blocking in the leg armor pieces, which, I think, is the most complicated section of the armor suit as there are many different "organic" metal shapes overlapping one another. I would suggest moving up a subdivision level at this point and flattening out broad edges with the Flatten tool, using a square alpha to give a chisel-type effect. This helps make armor layers pop out from one another, which is most noticeable in the upper leg armor and will help define boundaries when we crunch the sculpt down for later use (Fig.21).

Step**22**

Refine the plates more, running over the separation areas with a Standard brush and smoothing out trouble areas. Also quickly rough in areas like the arm plates, the abdominal muscles and armor plate details like bigger seams (Fig.22).

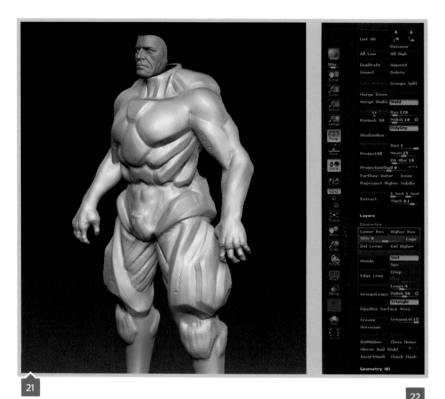

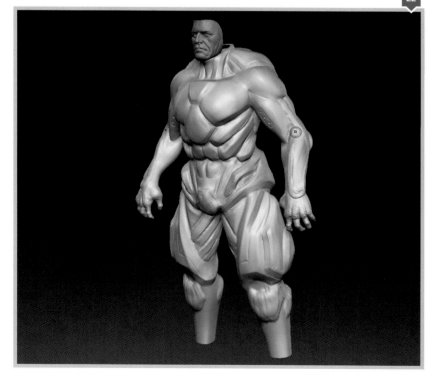

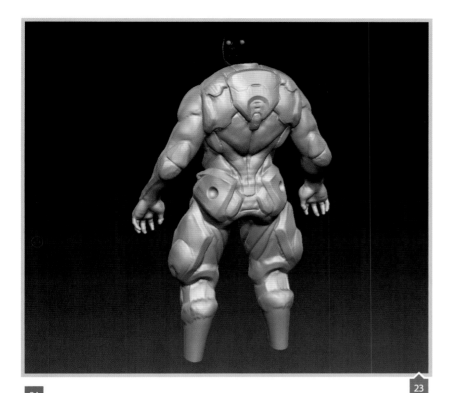

Step23

Now we want to carry this method over to the back panels of the character's armor suit. Focus on the main pieces, such as the central area and the overlapping shoulder blade pieces. You can rough in the back muscle details, but we will ultimately be tackling that in the final sculpt as one of the organic pieces like the arms and stomach. All of these pieces, like in the previous step, can simply be created by building up forms with the Clay Tubes brush, smoothing out trouble areas and flattening edges to give a sharper edge to the armor plates. Any surface detail at this point is basically just for visualization's sake and will be tackled in the final sculpt (Fig.23).

Step24

Refine the shapes, deepening dividing lines between plates that will be built out in 3D as separate models and sharpening edges up for better compression. Like the back armor, any surface detail is just to help visualize what the final version will look like (Fig.24).

Step25

Next we are going to drop the overall polycount of
the sculpt so that 3ds Max will be able to handle
the model better. To do this, I recommend using the
Decimation Master plugin provided by Pixologic.
With the body model activated in the Subtool panel,
navigate to Zplugin > Decimation Master. Here you will
set the percentage that you would like to reduce your
model by. You will need to select Preprocess Current
and then Decimate Current. If you enable Wireframe
mode by clicking the PolyFrame icon on the right side
of the screen, you should see the tool become lower
resolution. The difference between this and just simply
lowering the subdivision levels is that Decimation
Master will retain details as best it can while optimizing
the rest of the mesh. Subdivisions are broader changes
that can lose a lot of detail in the process. As a note,
this will kill off any subdivisions you have so it is
recommended that you save a backup copy of your
model just in case.

You can repeat this process until the model becomes a
resolution that is acceptable for your machine and 3D
viewport (Fig.25).

Export this new model as an OBJ and import it into
Max.

Step26

In the following steps I will be covering the armor
pieces by sections and breaking down the different
elements involved. The idea here is that I create a plane,
like how we began the original organic base mesh
in the first chapter, and essentially trace the armor
plates that we sketched out in ZBrush. In this step, you
can see the final true base mesh assembled together
(Fig.26).

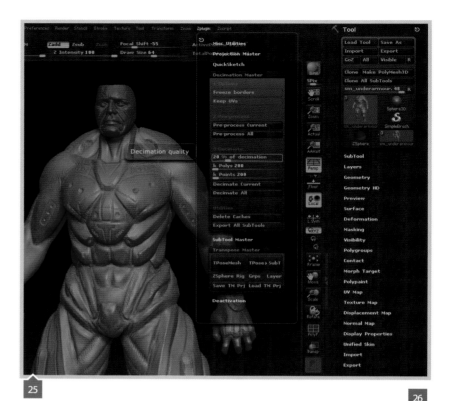

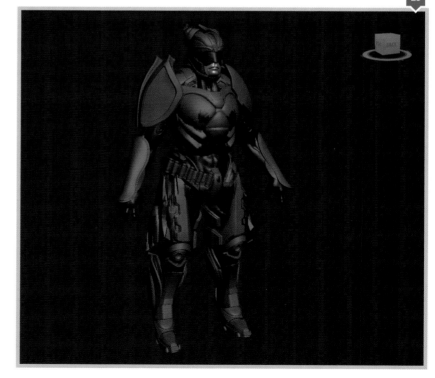

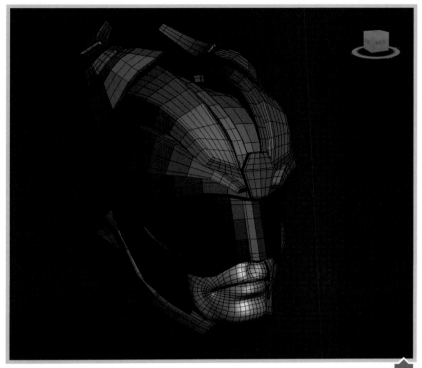

Step 27

Starting with the helmet, you can see there are many different armor plates causing a layer effect. We want to sculpt in many of the tighter plates and surface details, but keep the hard lines from the bigger plates that overlap on top of the head, the bridge of the nose and the antennas (Fig.27).

Step 28

As you can see, most of these pieces are fairly dense and have evenly distributed polygons for cleaner sculpting. Most of the sculpting performed on these pieces will be surface details such as bolts, seams and other grooves. For each element pictured here, a separate OBJ file will be exported in its "assembled" position, of course. For example, the visor, helmet base and antennas will all be separate files going into ZBrush (Fig.28).

Step**29**

Next is the chest. A key thing to notice for the armor, I think, is that the entire suit is practically symmetrical, excluding a few extra details like the bullet belt near the waist and the shoulder pads, which add a natural asymmetry to the design. This makes our lives much easier as we can basically model one half of each piece and mirror it on the X axis like we did in the first chapter (Fig.29).

Step**30**

For the chest you can see many different overlapping elements that I feel are necessary to keep the hard edges intact. We're focusing on the bigger, bolder shapes of the actual armor plates and will tackle surface details in ZBrush. A good rule to follow, I feel, is that if the model would be a separate piece in real life, it should be separate in the base mesh. Indents and ribbing can easily be added in ZBrush, as you will see in later steps (Fig.30).

29

30

Step**31**

The back armor focuses on bigger pieces, overlapping to create a faux shoulder blade look. For the moment we're going to leave the lower back exposed and tackle that in the sculpt. In the final, rigged product we'll want most of the midsection exposed/deformable so that the character can naturally bend. This would be a tough sell if the entire back were armored, so we will sculpt a spine protector into the under-armor (Fig.31).

Step**32**

The back armor has a few interesting points in the design, such as the subtle lip on the side of the main center piece and the main shoulder blade piece, which has a less rigid, more organic shape that conforms to the shoulder blade (Fig.32).

Step**33**

The right shoulder pad has a very interesting shape and is mirrored right down the middle, assuming that some form of connector is on the under-armor. For the shoulder pad itself, we're going to model in the strong recess and tackle the finer details in ZBrush (Fig.33).

Step**34**

The shoulder pad is simply two halves that will be exported as one OBJ into ZBrush. The forearm guard is a more organic, almost peanut-shaped, armor plate that conforms to the character's forearm. There are also two panels that hang down from this piece, almost as if they are grabbing onto the arm. For the forearm plate, I've decided to model in the rim, but this could also be done in ZBrush.

Mirror the forearm guard and its pieces over to the left arm and then export it as one piece (Fig.34).

33

34

Step 35

The left shoulder is a fairly simple shell split down the middle, much like the right side, and as a middle insert covering the deltoid muscle (Fig.35).

Step 36

I've decided to model a section that would mimic a connection point as it gives us an opportunity to add interesting detail. Even though we won't see and probably won't touch the underside of the armor plates in the sculpt, it's good practice to model it in as the final game resolution model will need that geometry to make the shoulder pads not look paper thin (Fig.36).

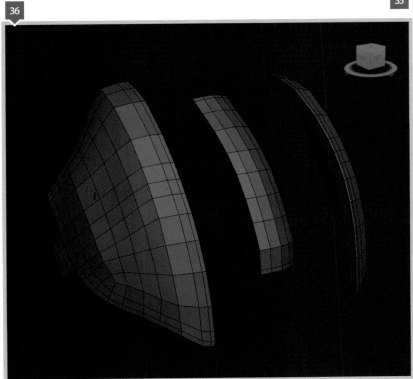

Step**37**

As mentioned earlier, the upper leg armor is probably the most complicated section of the armor suit due to its overlapping, intricate plating. As you can see, there are multiple organic metal pieces, curving inward as the armor nears the pelvis. There is as a plate that wraps around the leg, with tabs, connecting it to the outer leg sections (Fig.37).

Step**38**

We benefit greatly from simply modeling these sections as separate elements. Once blown apart, you can see that the many rather simple pieces combine to make a fairly complicated piece (Fig.38).

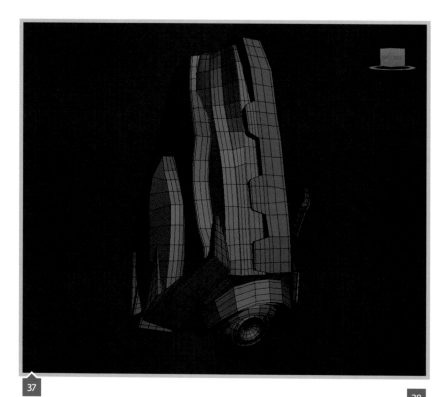

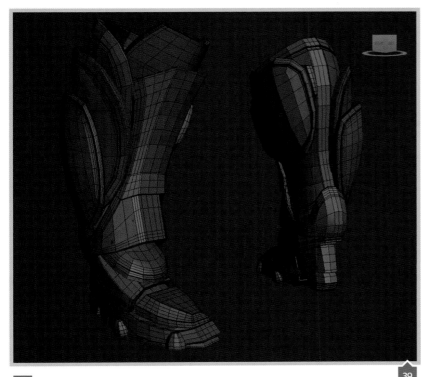

Step39

The last section is the boots for our character. As you may have noticed, I haven't bothered sketching this section out in the sculpt as I have a pretty good idea about how the model is going to come together (Fig.39).

Step40

The boot is mostly a skin-tight armor plate that has multiple shells layering outwards from its core. For deformation purposes, we want to keep the ankle fairly flexible, so cap off the ankle with a brace, which will allow the foot to move freely come animation time.

During the entire modeling process for these pieces, it's a good idea to toggle between subdivision levels to see what the model will look like once subdivided in ZBrush. Ultimately, though, you want to export all of the pieces at their lowest subdivision level (Fig.40).

Step**41**

Export all of the models as OBJ files and import them into ZBrush. You can either import each one manually or use the Multi Append feature within the Subtool Master plugin provided by Pixologic. The general rule I follow is that if the model is mirror, I export it together. So, rather than having a left forearm guard and a right one, I simply have one piece. The reason for this is that it means you can just activate symmetry in ZBrush (X) and sculpt both halves at the same time. This can be an issue on older machines, though, as the model itself will become heavier as you subdivide. If that's the case, you can easily export and sculpt one half, then mirror it over for the final presentation.

For each piece, subdivide it multiple times and get to work. Since most of our details are just on the surface, building up detail isn't as important as we've done most of that work already (Fig.41).

Step**42**

For the majority of the layered plate effect throughout this armor suit, we will be hand-painting masks and pushing them out, later refining them with the Standard and Flatten brushes. This is more or less a continuation of the techniques we used previously, but will be focusing more on individual armor pieces (Fig.42).

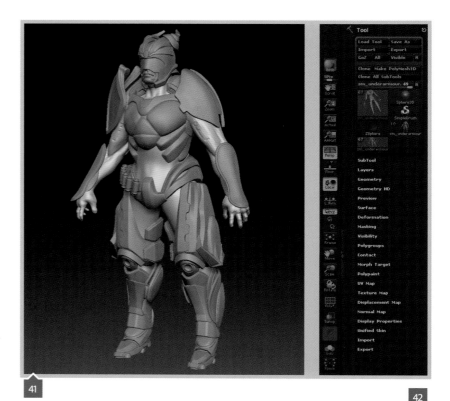

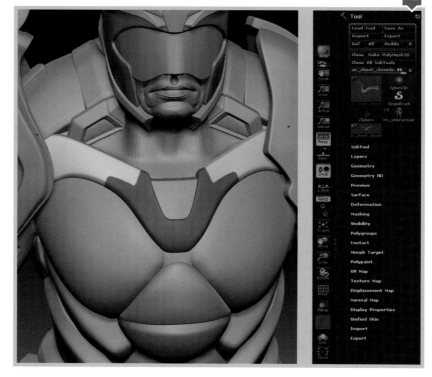

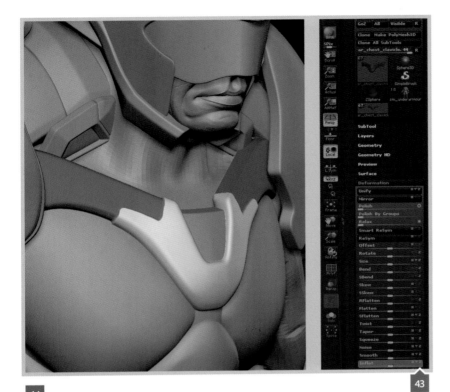

Step 43

Once the sternum center plate's mask has been painted, click off of the model while holding down Ctrl to invert the selection. This makes the unmasked part deformable. Next, use the Inflate Deformation modifier in the right-hand panel. You can either manually enter a number after clicking on Inflate or use the slider to enter the value you'd like. I always use this value in XYZ, though you can isolate an axis by simply clicking on its icon (Fig.43).

Step 44

Next, mask out the clavicle ridge and repeat the process of inflating it outwards. After it has been inflated, run a square Flatten brush along the inner edge to give it a more organic feel (Fig.44).

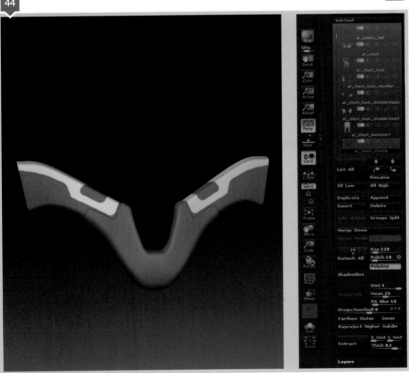

Step**45**

After this, mask out an insert section under the clavicle area and inflate it to a negative value, which will, of course, push the model in rather than out. Next, switch to a Standard brush and set the mode to DragRect. This will more or less stencil in a detail rather than painting on detail in a stroke. I like to use this for isolated details like bolts and other types of information. With a stock circular alpha, draw out three dots as indicated in the concept art. You'll notice that DragRect requires you to hold each stroke until the final detail is placed, rather than flicking your pen or mouse to draw out detail (Fig.45).

Step**46**

Continue this process for the finer details along the breastplate. Mask everything out and push it inward or outward with the Inflate deformer. For the really fine lines that lead to the deltoid area, use a Standard brush with LazyMouse enabled to achieve smoother lines (Fig.46).

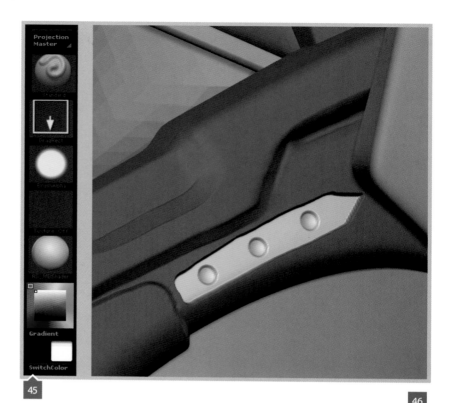

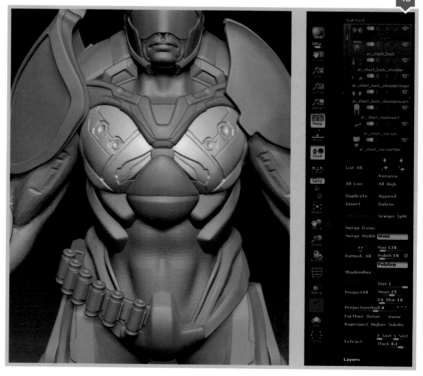

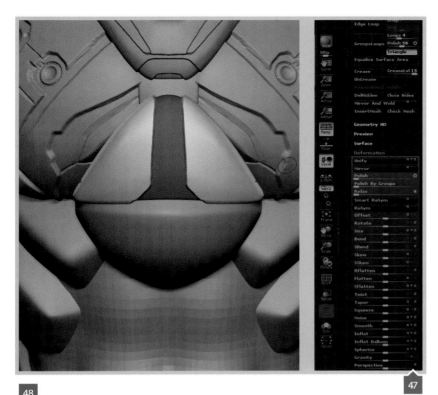

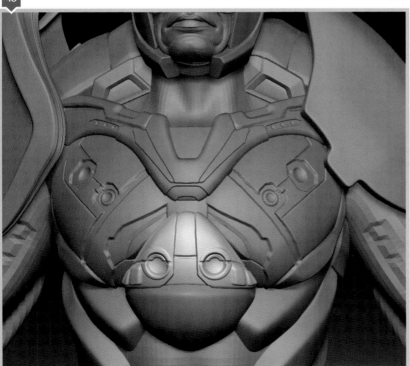

Step47

Next, mask out the panels on the sternum protector. To fully mask around the entire object, you may need to hide the other subtools. This can be done by holding down Shift and clicking over the subtool in the Subtool panel. This will hide all of the subtools that are not currently active. Repeat this process to unhide the subtools (Fig.47).

Step48

For the detailing, mask out square spaces and inflate them out. After this, create a custom alpha for the circular, port-type areas to be used with a Standard brush with a DragRect stroke type (Fig.48).

Step**49**

Continuing on with the lower half of the sternum protector, mask out and inflate the paneling detail, before creating a custom alpha for the triangular type indents near the center of the piece. As you can see, flattening out the edges and popping out grooves with a Standard brush really gives the model a stronger look and will eventually bake down better when we create our normal maps (Fig.49).

Step**50**

Moving on to the codpiece armor section, you can see a lot of the same theory carried through here. Mask out the main three plate details and inflate them out, rounding out the details with a Flatten brush (Fig.50).

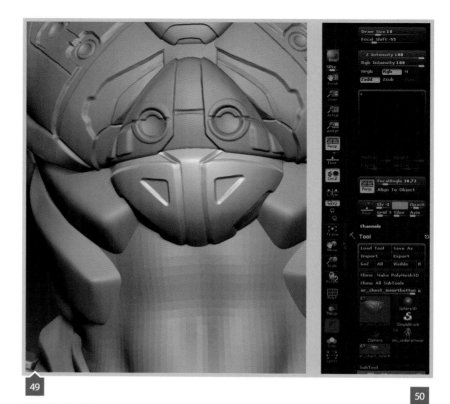

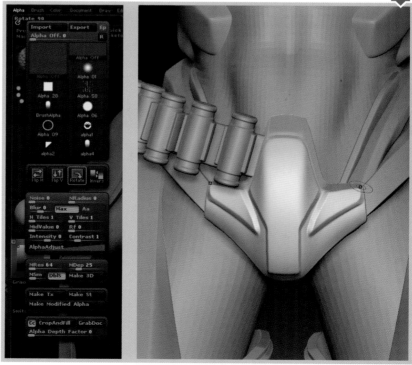

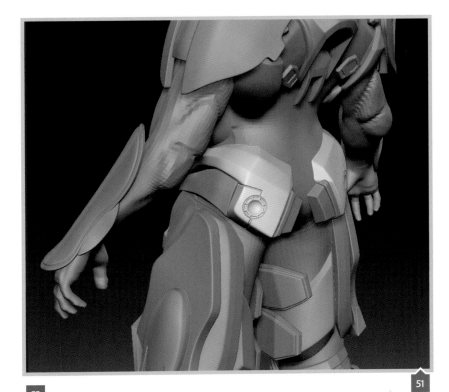

Step 51

For the most part, the hip armor is mostly finished. In the concept, these sections are fairly simply, as in they mostly consist of a streamlined piece with very little surface detail. This is great as it will allow the eye to rest and avoid the problem of just having a mess of random details that cause the character to be hard to read. There is one key detail, however, and that is the circular indent and the seam connecting the top and lower halves. For the circular detail, simply create a custom alpha and import it into ZBrush. For the seam, this can be painted in with a Standard brush using LazyMouse (Fig.51).

Step 52

The rib plates, like the hip sections, are fairly basic and are mostly done at this level. Mask in a section for the inside of the ribs, which will act as a home for an LED section, to give our character a material change. You can also bring out a nub, which could be interpreted as a connector point, as well as the seam which would assist with that detail (Fig.52).

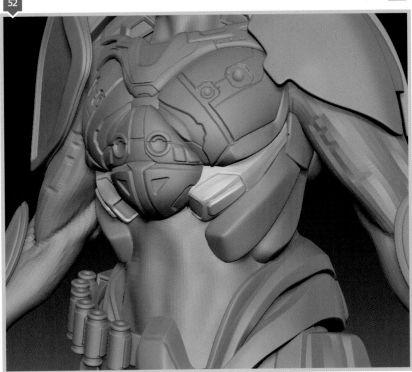

Step**53**

For the most part, we can repeat those steps on the next two rib plates, along with flattening out a broad section towards the top of each piece to give each rib plate a more organic feel (Fig.53).

Step**54**

At this stage you can also begin roughing in detail into the under-armor. I've basically smoothed down the under-armor where it would be clipping through, or nearly clipping through armor pieces, leaving the fairly exposed sections like the stomach and arms as a base for the final sculpt. Blocking in details, like the ribbing on the legs, will help you to visualize what the final product will be.

For the inner leg armor plate, mask in an indent towards the crotch to give some visual interest and add a small seam outlining the tabbed sections (Fig.54).

53

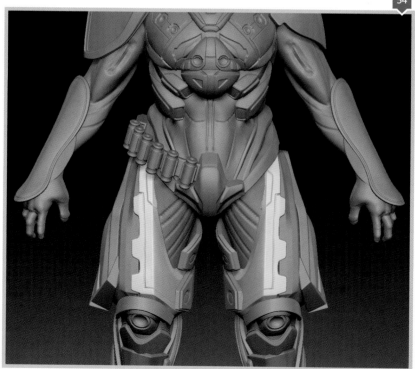

54

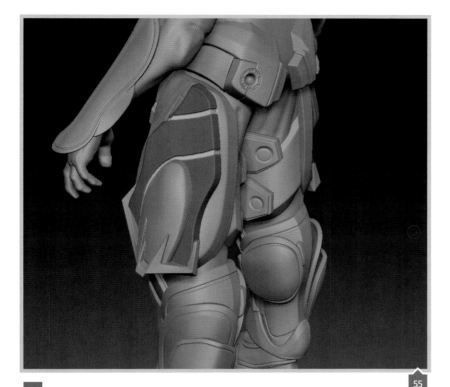

Step55

The outer leg armor has deep grooves to give a layered effect. To do this, simply paint where these plates would be and inflate them out. Performing this task the traditional way would take so much longer as you would spend time making the model's topology line up just right for a smooth subdivision. This method literally takes a minute (Fig.55).

Step56

Now, moving onto the dome plate on the side of the leg, mask out the outer insert shape and push it inwards with the Inflate deformer (Fig.56).

Step**57**

Repeating this process for the inner insert section, paint it out and inflate it with a negative value. If you find that your lines are not crisp enough when painting masks, you can enable LazyMouse for your masking brush. While holding down Ctrl to access your masking brush, navigate to Stroke > LazyMouse and enable it, adjusting its settings to your liking. Likewise, if you find that your masks are too sharp and are causing artifacts when you inflate the mesh, you can easily blur the mask by holding down Ctrl and clicking on the model (Fig.57).

Step**58**

The final composition for the leg armor shows that, really, the detail that we blocked out earlier is really enough information for this section. Adding too much fine detail can really become noisy and hard to read. Simply adding a few interesting surface details here and there can have a bigger impact than adding detail to every pixel (Fig.58).

57

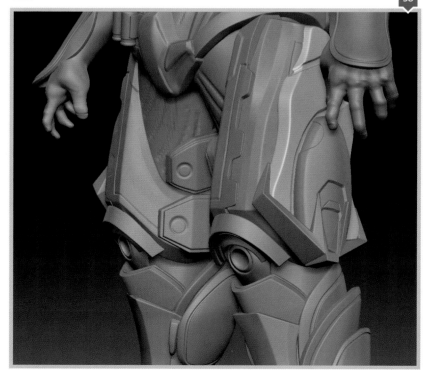

58

Step59

For the shin guard, push out a broad rim that surrounds the top of the plate and runs down the center of the shin itself. After this, add fine seams (which you'll see in the concept if you look closely) with a Standard brush using LazyMouse (Fig.59).

Step60

For the calf plates, push them in to close gaps using the Move brush. The reason for this, thinking ahead, is that it will be much cheaper to just model a low poly boot that surrounds this entire armored area, rather than modeling the shelves that would have been created with these gaps. This also barely changes the final silhouette (Fig.60).

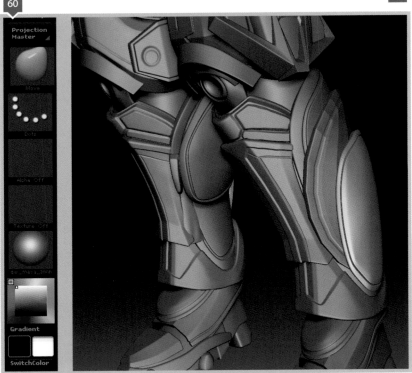

Step**61**

Most of the major seams have been modeled into the base mesh for the calf plates. To add a few interesting details, create a custom alpha (a coffin-type shape that is indicated in the concept art) and drop it onto each plate using DragRect. This creates a nice, subtle layered effect (Fig.61).

Step**62**

The boots can be mostly left untouched as most of the detail has been covered in the base mesh. Also, it is generally an area that doesn't have a lot of resources devoted to it as the feet are usually an area that most viewers don't pay attention to when playing a video game. That being said, you can go ahead and add a few seams at the back of the leg and the top of the boot. And I've also decided we should take out the detail connecting the boot and the shin armor that was indicated in the concept art as this will certainly prevent the foot from moving realistically in animations (Fig.62).

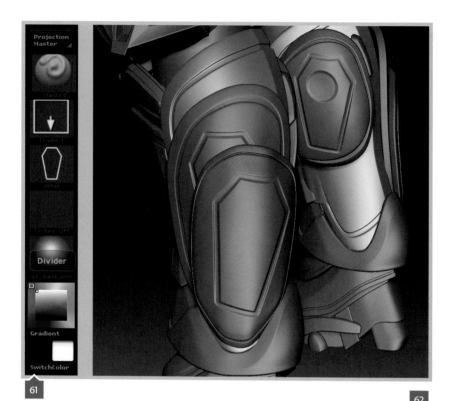

Step63

By comparison to other sections of the armor, the forearm plates are fairly basic and straightforward to detail up. Starting with the panels that come off to the side, mask out two chunks and inflate them outwards (Fig.63).

Step64

Next, mask out the inner shape, cutting it off at the outer trim seam that we created in our base mesh (Fig.64).

64

Step**65**

This is a great opportunity to bring up a problem about thin, double-sided objects. In ZBrush, if an object has a front and a back side, and those two sides are close together and you sculpt on one side, the opposite side will be affected. That is to say, ZBrush doesn't cull faces by default. However, if you go to the Brush panel and navigate to Auto Masking, you will be able to enable Backface Auto Mask which will remedy this problem. You may run into this problem with the forearm guard as you can't have the back masked out, but have the peanut shape in the front unmasked too (Fig.65).

Step**66**

With the final shape masked in, inflate the detail out and refine its shape with Standard and Flatten brushes (Fig.66).

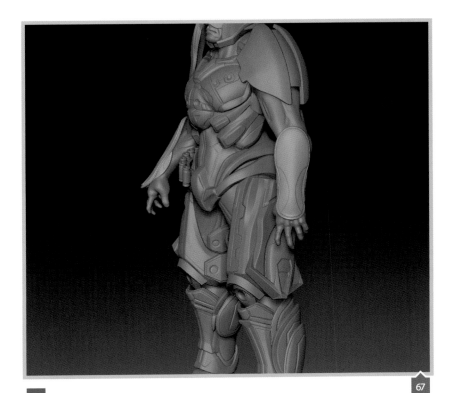

Step 67

It's always a good idea to take a step back from your sculpt and see how everything looks together, especially with a complex character such as this where there are multiple layers of detail (Fig.67).

Step 68

For the right shoulder pad, you'll notice that the symmetry axis for this model is a bit different. Not only is it on the Z axis, it is also off center. In order to make this work, we will need to activate symmetry in only the Z axis and enable local symmetry by clicking the Local Symmetry icon towards the right of the screen. This will use the object's center point rather than the world's center point (Fig.68).

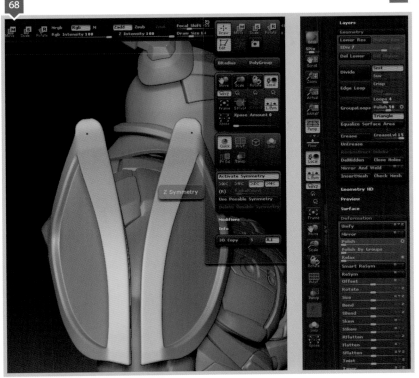

Step**69**

Begin by painting fine seams and masking out indentations on the rim of the shoulder pad (Fig.69).

Step**70**

There are some details hinted at on the mood concept image that I really like, such as the holes on the inner edge and the seam work on the frame in general. To translate that into 3D, we can simply use a Standard brush for the seams, as usual, and a circular blended alpha set to DragRect for the holes, tapering them in size towards the middle of the shoulder pad (Fig.70).

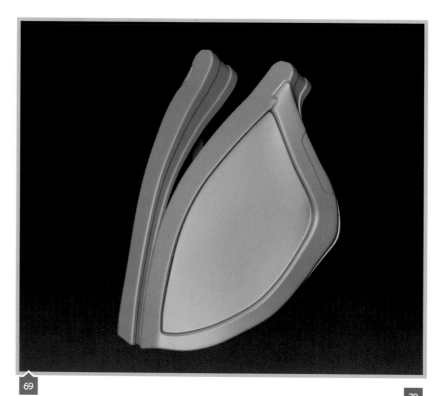

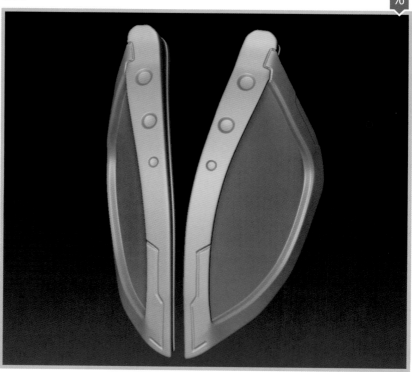

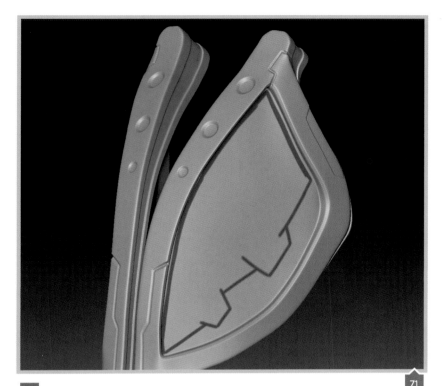

Step71

For the inner plates of the shoulder pad, I think it's best to mask out the major shape or the combined shape of all the plates and work in from there. So, to begin, mask it all out using LazyMouse (Fig.71).

Step72

Sadly, there's no quick and easy way to fill in a shell with the Mask tool. Though, I find it much easier to draw the outline first and fill it in with a bigger brush for the mask. Basically, like a coloring book, it allows you to keep the sharper edges caused by painting with LazyMouse and is a fairly quick way of covering big shapes (Fig.72).

Step**73**

As mentioned earlier, we want to invert the mask and inflate the entire inner plate outwards. This really makes the shoulder pad take shape and you can quickly see how the final product will look (Fig.73).

Step**74**

Next, reduce the entire area to include the last two plates and repeat the inflation process. Once that is done, reduce the masking to include only one of the plates and inflate it once again. The final result is a staircase-like look that will give the illusion of layered metal plates (Fig.74).

Step 75

Once all of the plates are pushed out, run a Flatten brush over the edge to mimic a beveled edge. After that, drop in a few details like holes, outer rings and thin seams with stock alphas and the Standard brush. For the inside of the shoulder pads, drop multiple square alphas using a Standard DragRect brush, being sure to taper them along the way to fit in between the ridges (Fig.75).

Step 76

The left shoulder pad has an interesting overlap for its armor panels. First, we're going to tackle the bigger section: the curves from the top corner down to the inner corner. Mask out this section, wrap around the inside of the shoulder pad itself and push out the sections themselves with Inflate (Fig.76).

Step**77**

Next, we want to paint the metal section that will be inserted into the shoulder pad by creating the mask and inflating the geometry inwards. This gives a nice organic result as the insert will conform to the previous plates (Fig.77).

Step**78**

Finally, add a few small details like screw holes and tapered holes towards the connector tab that is hinted at in the concept art. I've also created a unique alpha that I imported in, which is a stretched octagon that becomes our vents (Fig.78).

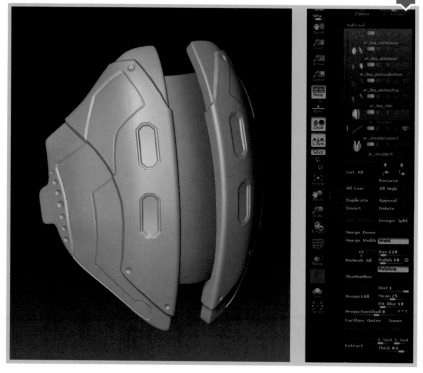

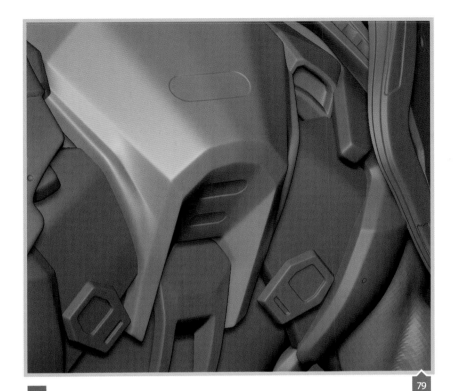

Step 79

Next, drop a few alphas down to create vents for the main backpack piece. These are custom alphas as well, made by elongating circles and importing them into ZBrush as a 2D, grayscale image (Fig.79).

Step 80

Create the seam up top, which hints towards the idea that this compartment can either be opened or overlaps here onto the lower piece, by freehand drawing with the Standard brush. For the inserts on the side of the pack itself, mask the objects out and inflate them inwards (Fig.80).

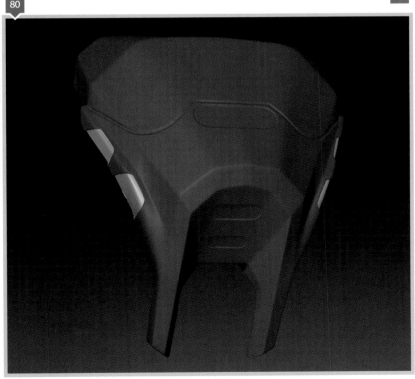

Step**81**

For the backpack insert simply hand-paint the masks, which is made easier due to symmetry being activated, and push those sections in (Fig.81).

Step**82**

Using a custom alpha for the center details and the stock circular alpha, use the Standard brush to finish off the surface details (Fig.82).

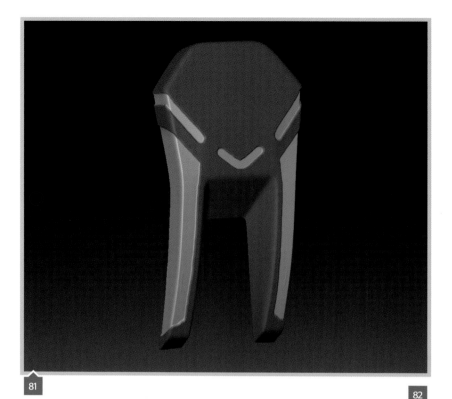

81

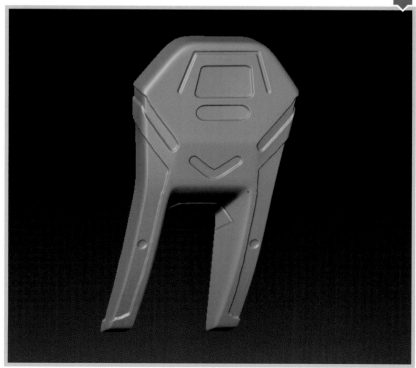

82

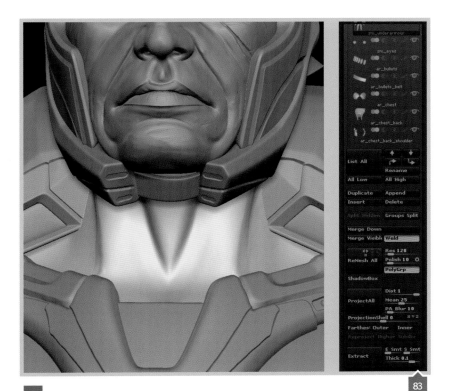

Step83

Skipping over to the neck, on the under-armor subtool that we created earlier, smooth out the area and flatten out the sternomastoid muscles by using a Flatten brush with a hard Square brush. This allows us to have a natural look to the neck area, as if it can still move slightly, but still hint to the fact that it is armored by adding these somewhat hard edges (Fig.83).

Step84

Next, using a Standard brush, draw in the ribbing that will allow this section to bend in on itself. Try to get each line as even as possible as, for the most part, it's all eyeballed. Don't be afraid to hide other inactive subtools, to overpaint detail here to hint that the ribbed detail would continue under the armor plates (Fig.84).

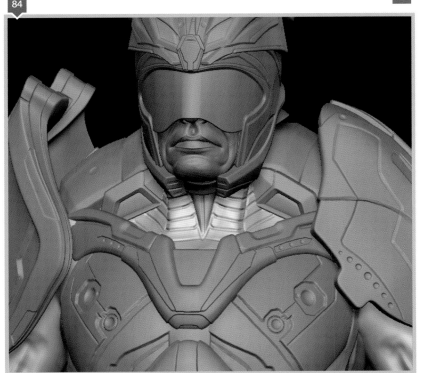

Step85

Moving down to the abdominal section, loosely sculpt in the muscle detail here, being sure to not go overboard as much of the material over the top of the flesh will hide these cuts. Once the muscles are blocked in, run over the surface with a higher intensity brush to create seam work that will allow the material to deform, and also adds a nice point of interest (Fig.85).

Step86

Moving around to the back, add some seams that roughly follow the flow of the back muscles on a human. You'll notice that there is a nice detail insert that will act as a spine protector in the concept. To tackle this, rather than using the DragRect Standard brush, let's use Projection Master.

Projection Master essentially locks your model temporarily on a 2D plane. From here, you can drop detail onto the canvas, which you can then move and scale, and also change the intensity and directionality of. To enter Projection Master, simply click on Projection Master in the top-left corner with your subtool active, enable Deformation and Normalized (just for this example – you can certainly use the other features in different scenarios) and click Crop Now (Fig.86).

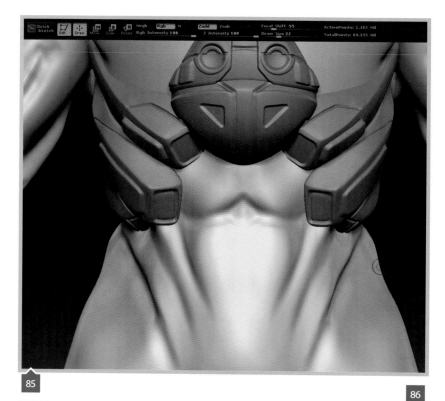

85

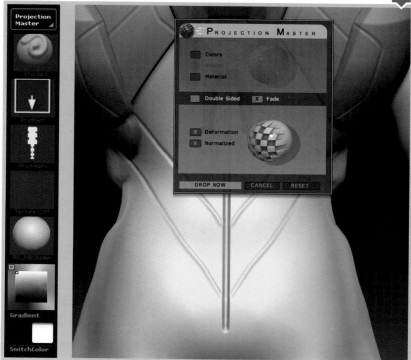

86

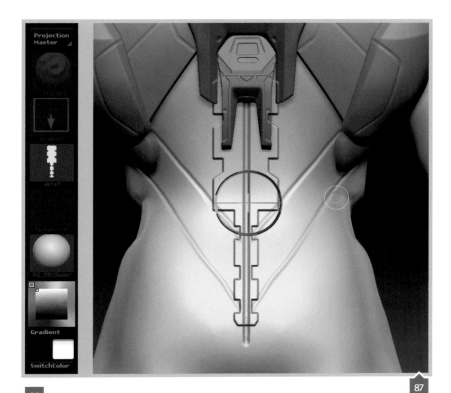

Step87

Next, import the alpha that you've created, which consists of tapering hard edges that mimic the human spine, and draw it onto the canvas. This should seem familiar as it is practically the same as the DragRect Standard brush function, just much easier to control in this situation and with the ability to alter the information after it has been drawn onto the canvas (Fig.87).

Step88

Once that detail is in place, click on Projection Master again and select the Pick Up option. This will convert the details on the 2D canvas onto your 3D model. Once this is done, mask out the panels that run from the spine to the delts and inflate them outwards (Fig.88).

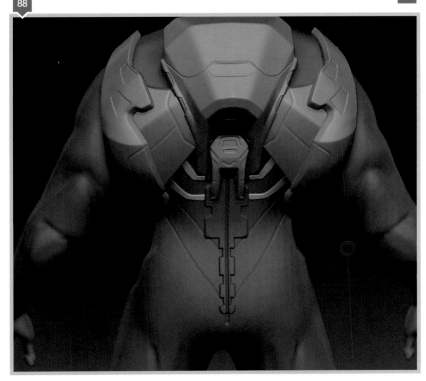

Step**89**

To finish off the back, draw in a few seams with a Standard brush that just help break up the area (Fig.89).

Step**90**

Moving on to the helmet, we're going to start with the antennas. Add the seams freehand to give the impression that this piece could come apart and is even daintier than the other armor pieces. Also mask out the inner section, which will be pushed inwards and detailed up (Fig.90).

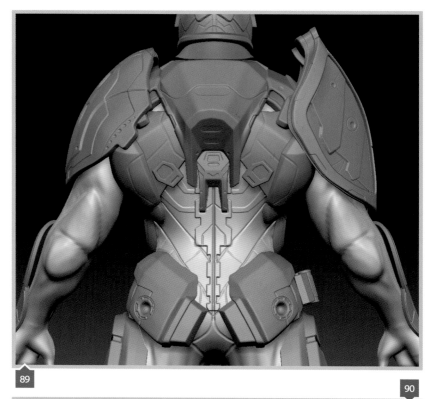

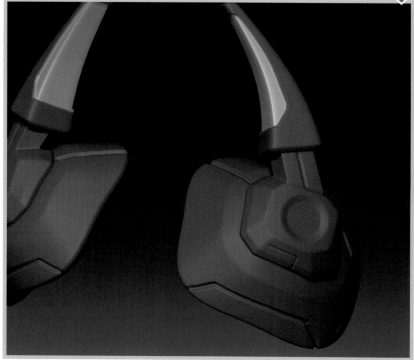

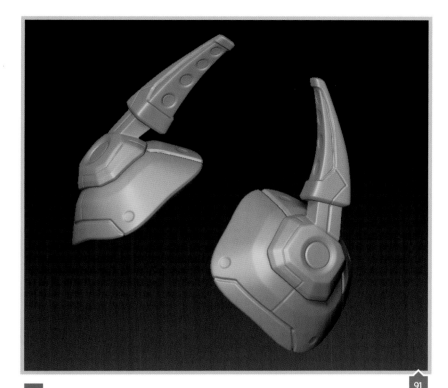

Step 91

To finish off this section, drag in circular details for bolts and pieces that hint towards receptors or some type of communicator. Punch up the details by running a Standard brush over them, for the most part sharpening grooves (Fig.91).

Step 92

Moving on, the nose bridge armor has a fairly interesting pattern in the concept created by bulking up the metal plate with different layers. The armor band running along the top of the head is also an interesting piece in that it has a nice organic curve that, I think, helps pop it out from the otherwise sharp-looking helmet. Once you've painted the curve, mask in the inserts and push them inwards, polishing them off with a Flatten brush (Fig.92).

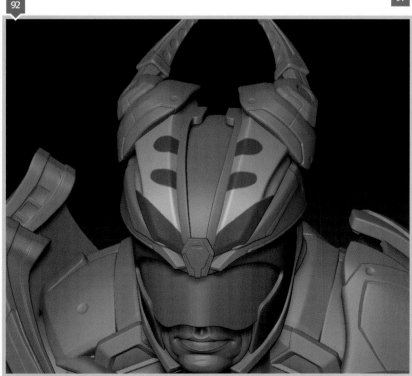

Step**93**

For the remaining armor plates that we have created
base models for, sculpt in a few seams with a freehand
Standard brush. For the center plate on the top of
the head, use the Stitch brush with a circular alpha.
The Stitch brush acts much like a Standard brush with
LazyMouse enabled; just that rather than painting a
solid stroke it will space out the alpha equally, making
it ideal for repeating patterns like stitches and bolts
(Fig.93).

Step**94**

Moving on to the base of the helmet, the process for
creating the plated materials that are close to the
head resembles the same procedure done on the right
shoulder pad. First, paint out the bulk shape of the
plates and inflate them outwards (Fig.94).

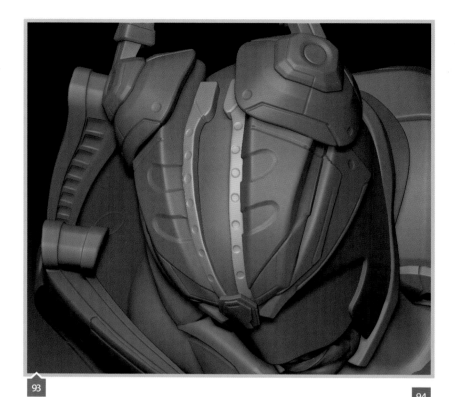

95

Step95

Once this is done, reduce the selection by masking out the lowest level plate and push the new section outwards, repeating the process for the last plate (Fig.95).

Step96

Taking a step back, we can really see the helmet coming together and how all of the details are working once all of the pieces are visible (Fig.96).

96

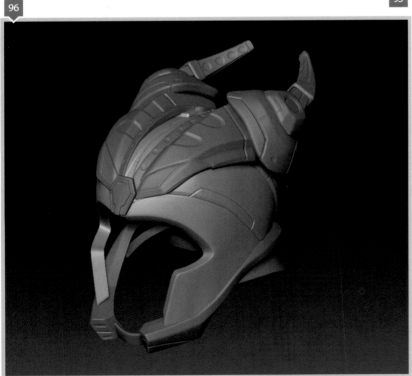

Step**97**

Next, mask out the armor piece that wraps around the brow line and down towards the jaw (Fig.97).

Step**98**

Once all of the panels are sculpted out, give the entire helmet a polish pass by beveling the edges with a Flatten brush and strengthening the grooves with a Standard brush. At this point you can also add in finer details like seams and bolts, as well as the seam work that spans from the bridge of the nose and goes over the brow (Fig.98).

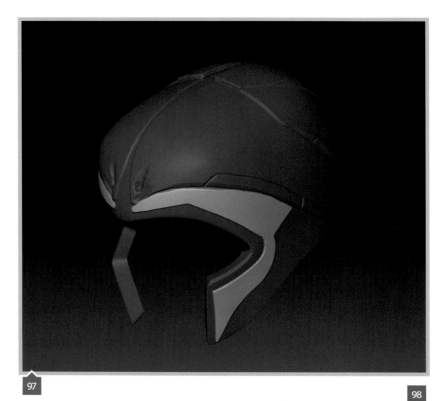

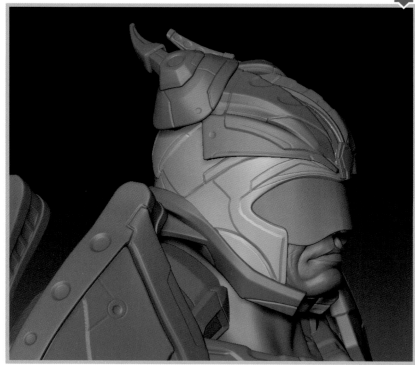

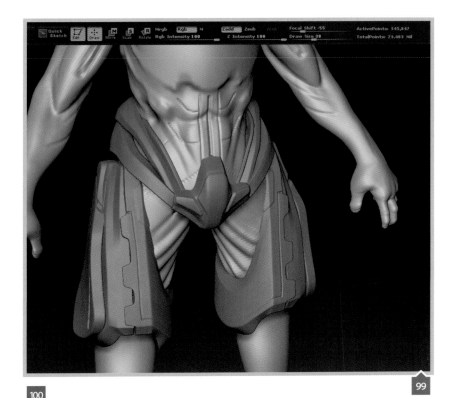

Step99

Moving back to the thighs of this character, block out the ribbing hinted in the concept art by running a Standard brush, with LazyMouse activated, from the crotch down towards the knee. Use a fairly low intensity here so as to not push the detail out too far (Fig.99).

Step100

Next, move up in subdivision levels and deepen the creases between these ribs with a higher intensity brush. Also run a Flatten brush over the panel closest to the pelvis as this will be a different material (Fig.100).

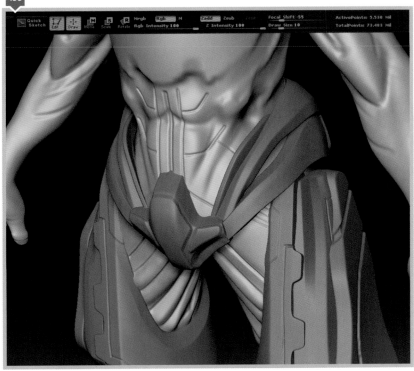

Step**101**

Mask out each rib individually and bring in a custom alpha that consists of connected octagons. Using a DragRect stroke type, drag this detail at a low intensity over the exposed area (Fig.101).

Step**102**

Repeat this process for each ribbed section, smoothing out the area using a low intensity brush after the fact to remove any obvious artifacts. The idea here is to just introduce a new material that will stand out from the metal plates, but not be overly distracting. The webbing also hints to the fact that this area is probably less armored as it needs to be able to move freely (Fig.102).

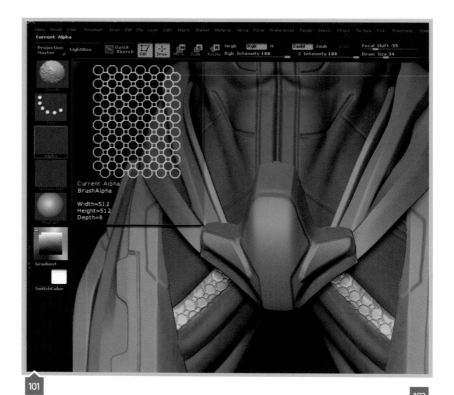

101

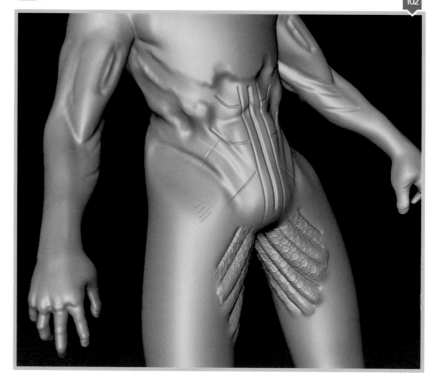

102

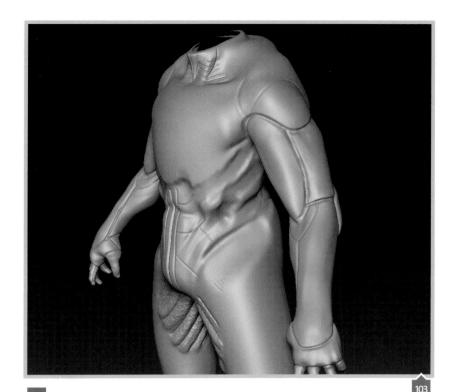

103

Step 103

Continuing on with the organic material body armor, most of the muscle detail has been blocked out in our sketch sculpt. Refine these areas by smoothing them out where needed and then use a Standard brush to draw in the different sections, which hint towards padding in the suit and construction that allows the human underneath to move around (Fig.103).

Step 104

Bevel these areas with a Flatten brush and refine the seams with a Standard brush. After this, incorporate a panel on the bicep (which is indicated in the concept) by masking out a rounded rectangle shape and dropping in port holes with a DragRect brush and circular alphas. Also mash the inner elbow and drag in the webbing pattern we used on the thighs. Reusing this material helps show that it is reserved for deformable areas (Fig.104).

104

Step**105**

Next, mask out the edging detail on the forearms and inflate them out. For the most part, these details will be hidden by the forearm plate itself, so be sure to double-check that the information you're creating will be seen (Fig.105).

Step**106**

Next, mask out the knuckles and inflate them. This creates the idea that these joints are at least slightly more armored than the basic pieces (Fig.106).

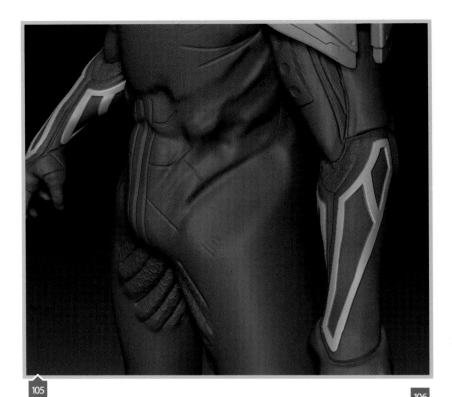

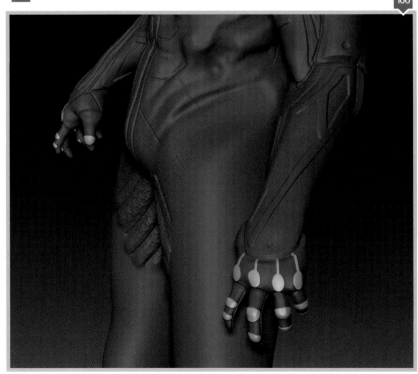

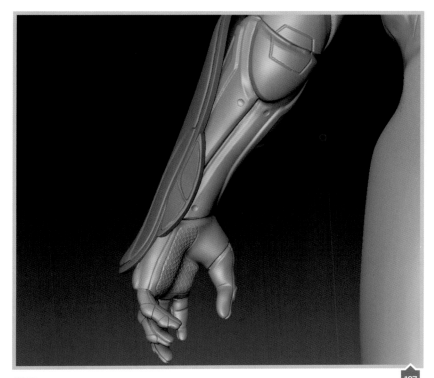

Step 107

Finally, to finish off the model, mask out the palm and add the webbing pattern to this area as this is a thin spot in the armor suit. Also punch up the seams and add some bolt holes showing where the padding could be fastened to a more comfortable layer underneath (Fig.107).

Step 108

Here we can see the final sculpt all together (Fig.108).

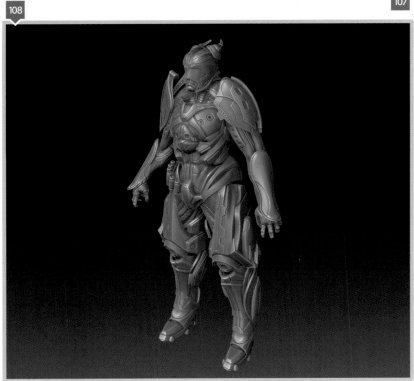

Step**109**

Now, we begin on the accessories. To start off, make the cape base model. The base model for the cape is fairly straightforward. Using the character base mesh as a guide, create a loop of polygons and work loops out from there to cover the clavicle and work down the back. Remember to curve the cape slightly as it reaches the calf area (Fig.109).

Step**110**

Append the cape model as a separate subtool for the sculpt we've been working on and subdivide it a few times (Fig.110).

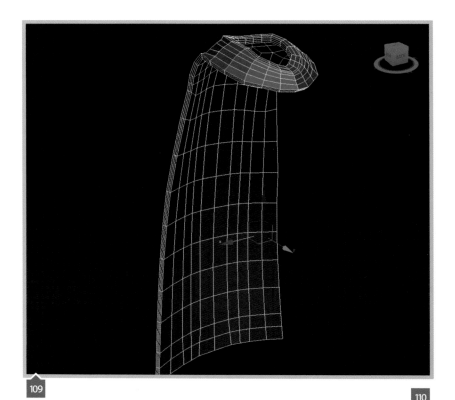

109

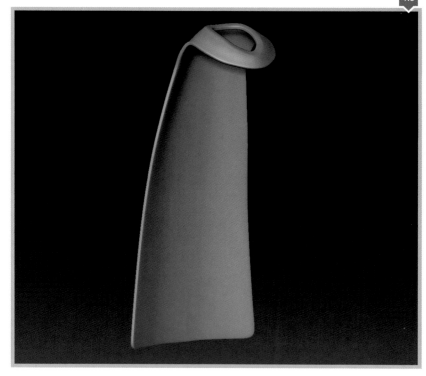

110

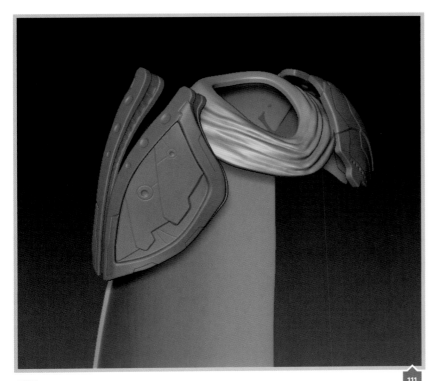

Step 111

Now, begin working on bigger folds with a Standard brush, keeping in mind how the fabric would bunch up around the neck when compressed (Fig.111).

Step 112

Paint in large strokes that are tighter next to the neck and in broader, more subtle strokes towards the bottom. The reason for this is that the fabric would swing more freely if not compressed like it is next to the shoulders and, since the cape will eventually be rigged to animate, we want to have as few wrinkles as possible so that they don't conflict with how the cape would move and compress during animations (Fig.112).

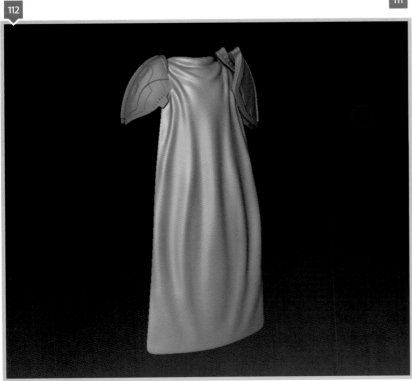

Step113

Once the folds are blocked in, increase the subdivision levels and refine the shapes with a tighter Standard brush (Fig.113).

Step114

Here you can see how the sculpt will fit the final character (Fig.114).

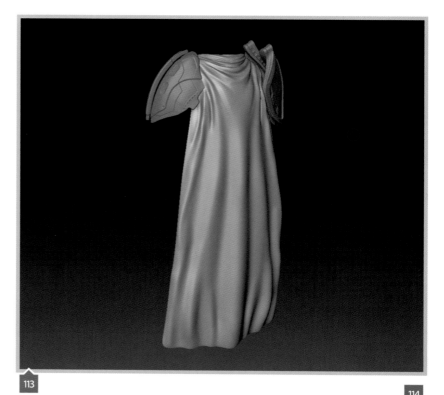

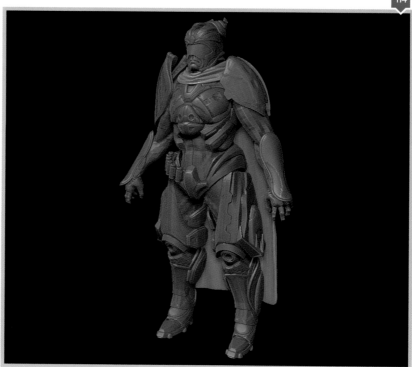

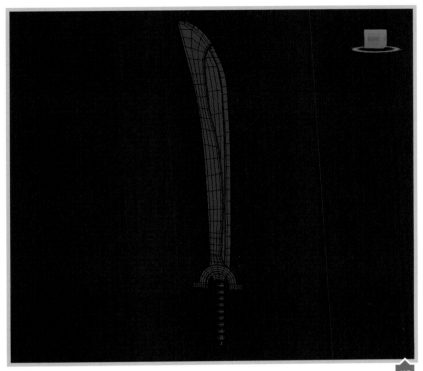

Step 115

Now we move on to the character's weapons, which include a technologically advanced sword and a smaller gun for ranged attacks (Fig.115).

Step 116

Much like the body armor, you can see that the sword is composed of many different elements. I find that it is just easier to iterate this way if need be, since different portions of the model can be swapped in and out, as well as maintaining edge fidelity since sculpting information won't bleed from one section to another. As you can see, I've tried to carry the armor style over into the weapons to give it a consistent look, as if the entire set was issued to this particular warrior (Fig.116).

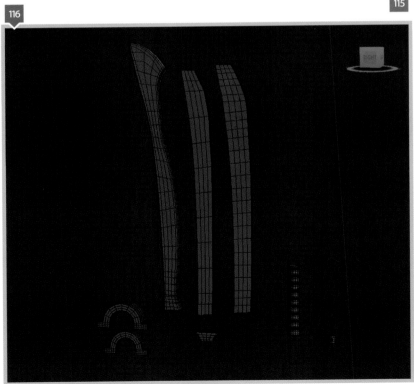

Step117

Import all of the separate models as OBJs and construct a new tool file by using the Subtool Master Multi Append feature. Once all of the models are brought in, subdivide them a few times and get to work on detailing up the sword hilt with tapered holes, which can also be seen in armor pieces on the character (Fig.117).

Step118

After this, freehand in a seam detail on the hilt and move on to the actual blade of the sword. Run a Stitch brush over the edge with a tabbed alpha that will be used to create a serrated blade, which I think makes the blade look more menacing. Next, grab the plate that creates the back of the sword and mask in an insert that will act as a brace for the serrated blade (Fig.118).

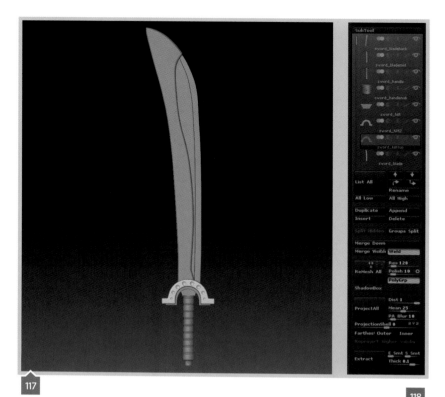

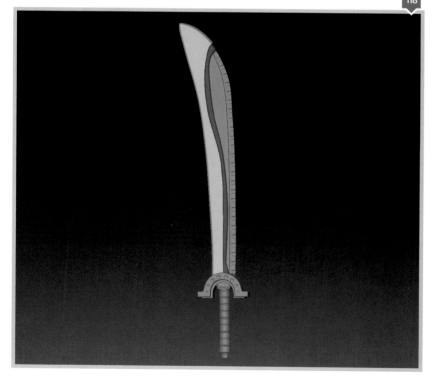

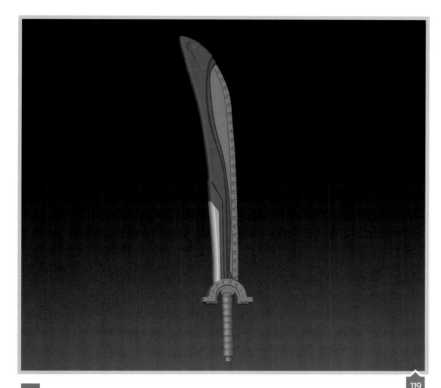

119

Step119

With this same section selected, mask out a layered plate effect towards the hilt and add a few accents towards the top of the blade (Fig.119).

Step120

This is the final sword sculpt with a more metallic material (Fig.120).

120

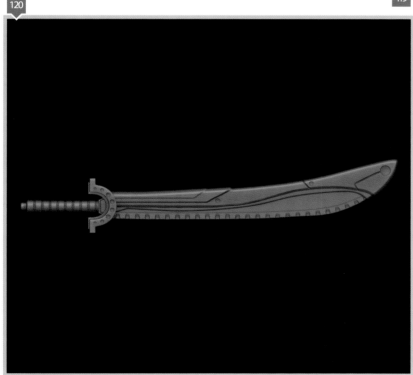

Step**121**

Now we move on to the gun, which is like a heavy-duty machine pistol. The idea behind this gun is that it can be handled with just one hand, but also has the option to use the off-hand for stability. I think having a bigger gun that would require two hands would defeat the purpose of the sword and the Swordmaster (Fig.121).

Step**122**

Like the sword and the armor suit, the gun is split up into many different elements which, for the most part, begin in the center and layer out to the top. Most of the shapes are fairly simple geometry and don't get too caught up in finer details (Fig.122).

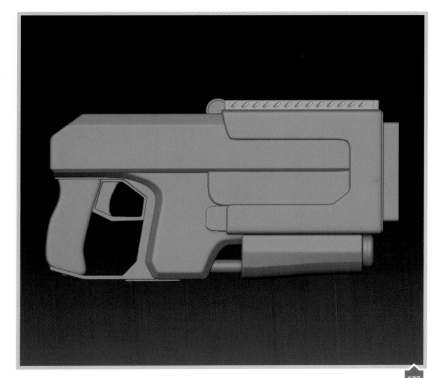

123

Step123

Import all of the models using the Multi Append feature and begin a new sculpt. For both the gun and the sword, you can simply use the character model as a scale reference and handle the weapons as separate sculpt files so as to not bog down the character sculpt.

Begin the gun sculpt by using the Stitch brush and a custom alpha, which consists of a rounded rectangle turned 45 degrees and faded, to create the vents on the top rail section (Fig.123).

Step124

Next, lay down some surface details like seams and bolts. After this begin masking out sections to be pushed in and out of the gun body (Fig.124).

124

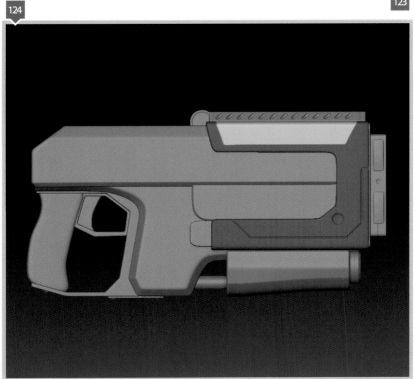

Step**125**

Continue on with surface details, adding rivets, seams and a serial number plate. Moving on to the gun front grip, mask out sections as I have done and draw the rubber grip bubbles with a Stitch brush to keep the spacing even. Once a stroke with any brush has been started, if you hold down Shift it will lock the brush and allow you to paint in a straight line. Of course, pressing Shift before the stroke just activates the Smooth brush (Fig.125).

Step**126**

Next, drop the model using Projection Master and lay down details such as the top slots and smaller panels. These use custom alphas we have already used and stock alphas from the standard ZBrush alpha library (Fig.126).

Step**127**

From here, paint in vents, like on the rail, with a Stitch brush using the same alpha. You can rotate, invert or flip an alpha image in the Alpha tab at the top of the screen. This helps save time as you won't need to alter your alpha in Photoshop.

Moving on to the grip, mask out a section and inflate it with a negative value to bring it more flush with the trigger area. Also draw in a bolt using alphas that we have already created, and mask and inflate the rubber grip section of the handle (Fig.127).

Step**128**

Finally, add finishing touches like cleaning up seams, the rubber grip and scratches from wear and tear.

This completes the high resolution modeling portion of the series. From here, we will be moving on to the game resolution model and will be covering topology, deformation and polycount (Fig.128).

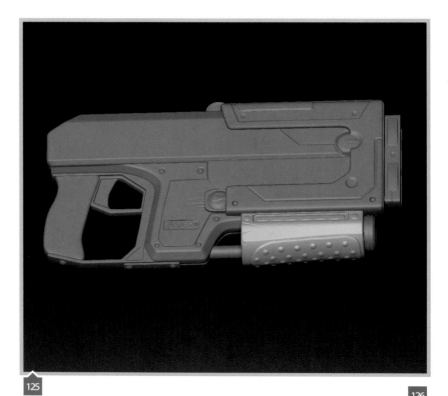

125

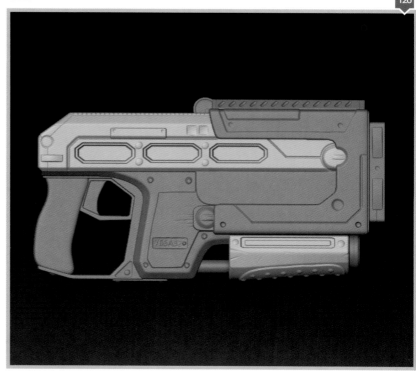

126

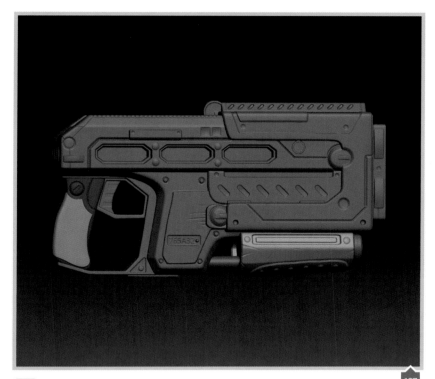

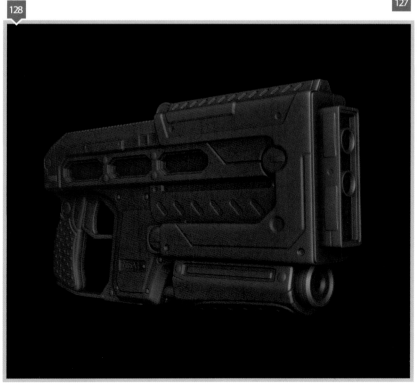

SidebarTip: Alternative Subtool Management

If you have a higher end machine that can handle many subdivisions on heavy objects, you may be interested in creating Polygroups. Polygroups essentially split your model into separate elements for easy selection and manipulation, without creating a bunch of different subtools.

Navigate to Polygroups in the Tools panel, with the subtool that you would like to alter enabled. Here you can choose Autogroups, which will group your model based on geometry seam (e.g., if you have a piece of armor with multiple plates, each plate would then become a group). You can also select Group by UVs, which will split the model into groups based on UV islands. I find that, if you are going to use the UV method, it is best to create these UV islands manually in your 3D application, as it will give you more control.

You can also use GoZ to switch this model from ZBrush to your 3D application, split the model into different elements or adjust its UV layout, then easily switch back to ZBrush with GoZ and have these changes usable by the Polygroups feature. Simply navigate back to the Polygroups section and recreate the groups.

Once the groups are created you can press W to see the wireframe of your model; the different colors shown will indicate different groups within your ZBrush model. To hide the mesh within a group, simply press Ctrl + Shift and click on the group you wish to use. This can be helpful for isolating areas that you would like to work on without affecting other pieces, as well as masking out larger elements.

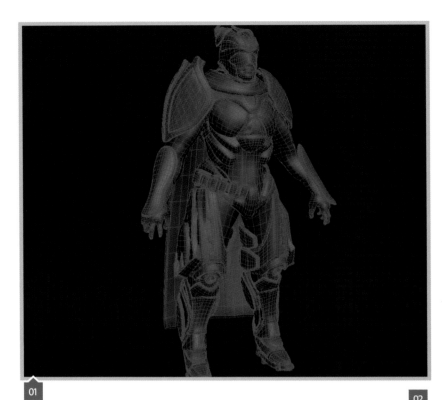

01

CHAPTER**THREE**
CREATING A GAME MODEL

Introduction

In this chapter we will be creating the actual in-game mesh (also known as a render mesh) that will eventually be posed and presented as if it were a true character asset for a current generation video game.

I like to begin my low poly models by bringing in the ZBrush model at its lowest subdivision level. This gives you a pretty solid guide to start from and means you can more or less trace the model when creating the final game mesh. This is a similar philosophy to the one exercised in previous steps when we created a cleaner base mesh from our sketch sculpt.

Step**01**

Before modeling, analyze what the low poly model will actually consist of. Think about where you can duplicate objects, which parts are symmetrical, where you will need to put natural geometry seams for better unwrapping, and how much you can accomplish with simplified shapes and fewer overlapping pieces, etc.

It is also important to note that the three key points to low poly modeling are having a model that:

 1: Falls under budget (this depends on the nature of the model; in this case we are going to go a

02

little higher than normal as this model would be considered a hero character and ultimately a portfolio piece.

2: Easily deforms (focusing on proper topology so that the character can have enough geometry to bend/retain shape when animated and still be within budget).

3: Has enough geometry to capture details from the high resolution model without too many artifacts (going too low can cause baking errors; going too high can break the budget).

All of these things need to be accomplished while maintaining the rough silhouette achieved in our sculpt (Fig.01).

Step02

Not all of the pieces of this model will need to be created from scratch. Many pieces can be created quickly by removing unneeded edges. An example of where this will work is the character's visor (Fig.02).

First split the entire thing down the middle by removing half of the faces on one side and removing all of the back faces that gave the sculpt depth. The key here is to retain the rough shape of the model without making a mesh that is too dense (Fig.03).

For the most part the visor is practically a straight plane running from the forehead to the nose. Therefore you don't need a lot of geometry to keep its original shape. However, as the visor wraps around the character's face and has a slight curve on the bottom, more vertical edges are needed to keep this shape nice and smooth.

Step03

Once all of the unnecessary edges have been removed, the model can be duplicated and mirrored on the X axis (Fig.04).

Step04

The two halves are then combined into one solid mesh with the vertices welded down the middle. This is basically the same technique that will be carried out in all future steps. The character is mostly symmetrical in either the X or Y axis, excluding a few details that are layered over the top of the original model, which will be handled separately (Fig.05).

Step05

Moving on to the helmet itself, take a face off of the original model and begin building out using the edge extrusion method shown earlier (Fig.06).

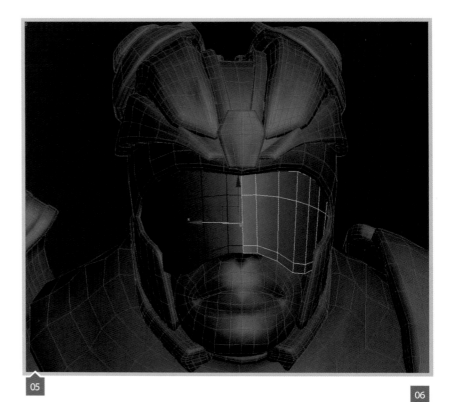

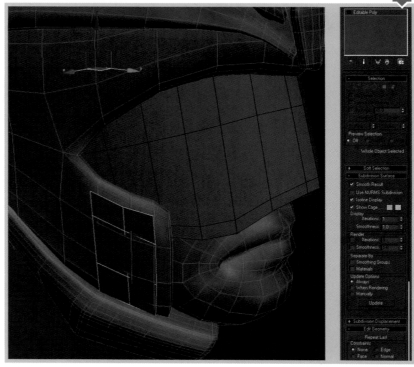

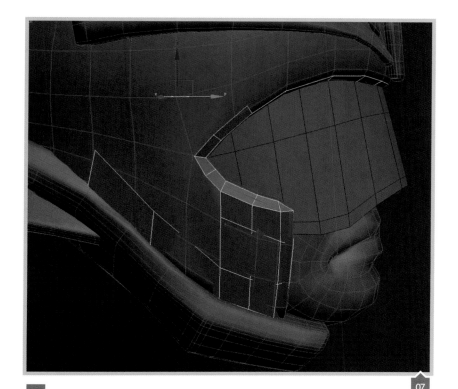

Step06

Create edges where the jaw protector will need to be modeled and line the inner edge of the brow line. From here extrude edges out to the overlapping fins, which will all be incorporated to one solid mesh (Fig.07).

Step07

Wrap the edges around the back of the head again, using the base model as a guide for where to drop the edges. The key here is to roughly mimic the base shape we had on our model, with the game resolution faces lightly intersecting the original model (Fig.08).

Step08

Extrude edges up around the cranium portion of the helmet to act as a sort of anchor point for all of the other details that will need to be incorporated. This helps avoid any rough edges and headaches. Once these edges have been placed, begin building out from there and model around the fins on the side of the head. You only need to be concerned with the bigger, lower frequency details here; as the smaller details in our model will just be in the Normal map (Fig.09).

Step09

Building from the larger fin, move on to the lower portion and run those edges down to the front of the helmet. At this stage build out the jaw protector and neck fin, which are all still part of the one helmet mesh (Fig.10).

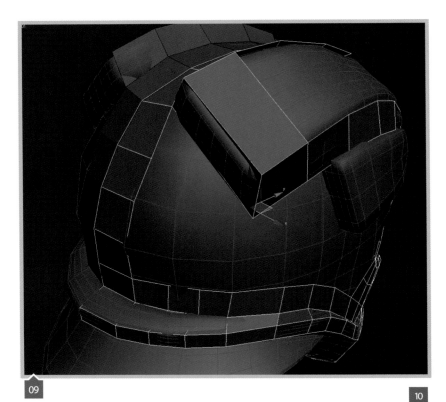

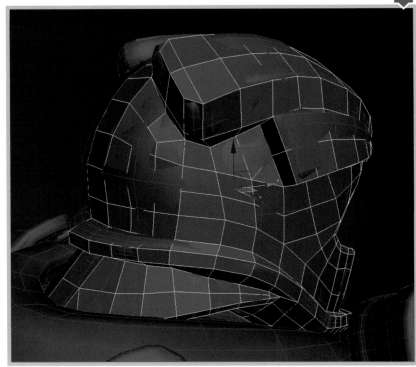

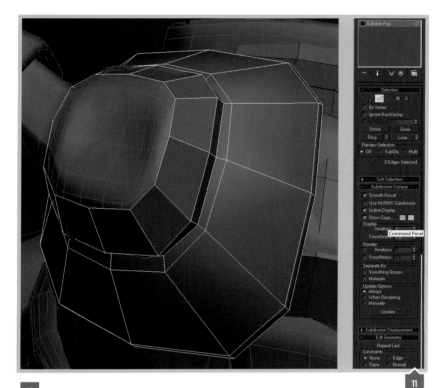

Step 10

The only floating portions of the helmet other than the visor that can be removed or added for character variation are the antennas at the top of the head. For these, much like the visor, split off the base portion and remove most of the horizontal and vertical edges. Model the layered effect that was in the model section by section until you cap it at the top of the model. This adds to the visual interest and makes it easier to add the actual antenna horns (Fig.11).

Step 11

Grab a few faces from the back of the antenna base and extrude them outwards to match the general flow of the antennas. From there add the layering effect from the actual antenna to the chunk connecting it to the antenna base (Fig.12).

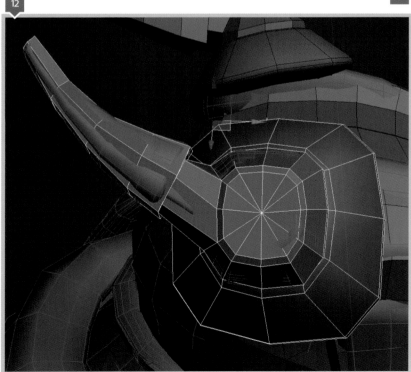

Step**12**

Move on to the face. Excluding the under-armor sections, this is the only organic section of the model. Unlike the armor pieces there is more of a focus on proper topology here as the mesh would ideally need to be able to deform when animated. Generally hard surface objects like armor plates do not bend, so the focus for them is usually retaining a smooth shape rather than continuous edge loops.

To begin, grab a face off of the bridge of the nose and create a separate object. Instance that object on the X axis and begin adding some depth by building outwards using the edge extrusion method (Fig.13).

Step**13**

Move on to the line of the nose and work towards the edge of the lips, adding a few edge loops that will eventually circle the entire mouth, much like the muscles that work underneath the skin (Fig.14).

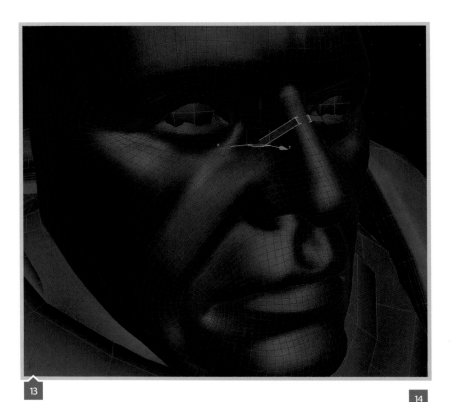

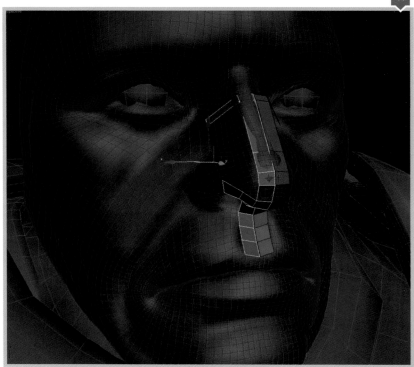

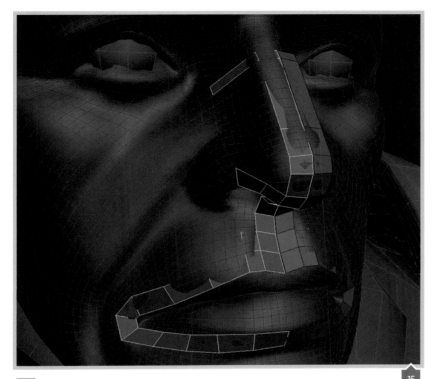

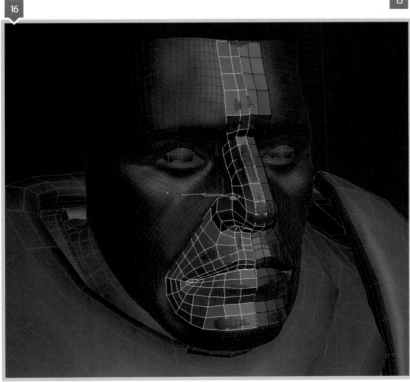

Step 14

Next extrude a ring around the character's lips, keeping the same rough shape as indicated in our model. Try to devote enough geometry to the mouth, so that it can squash and stretch as needed when being animated during expressions and lip syncing. Devote a few edges to the corner of the mouth. You should do this by adding one edge between the lips, and one for the top and lower lip (Fig.15).

Step 15

Extrude the edges inwards to complete the lips, adding one edge circling on the lips to give them some depth. From here build outwards using the borders we previously constructed to start forming the chin and nasal folds. Give the mouth two or three loops around the outside and terminate the third with a star just under the corner of the nose, as it is a relatively safe area to have five edges connect (Fig.16).

Step**16**

Next build out edges over the nostrils and continue them down the cheeks. I find this helps define smile lines and the fat a character like this would have in this section of his face. It is also an area that can stretch along with the mouth, so continue the edges right down to the chin and neck (Fig.17).

For the most part try to connect the eyebrow muscles to the top corners of the upper lip with a few edges. This will help retain the face's natural shape during extreme stretching poses and will also help that deformation seem more natural, as the flesh on a character's cheeks is generally affected when the mouth opens and closes (Fig.18).

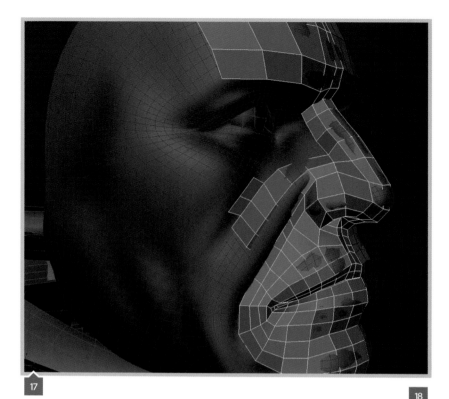

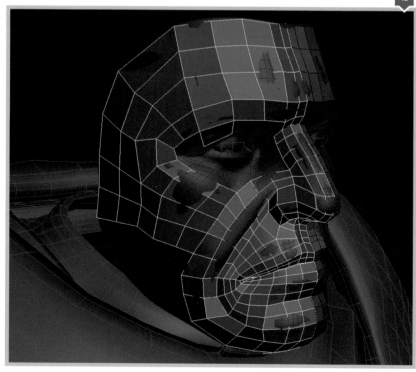

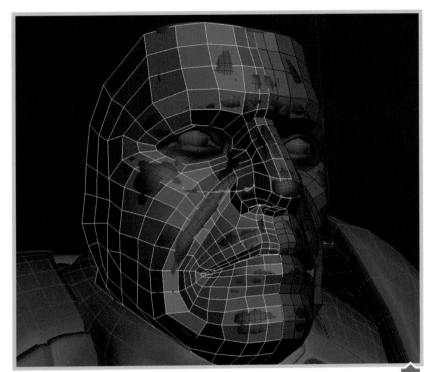

Step 17

Next create the eye sockets and begin to outline the general shape of the eyeball and lids, as well as extrude the boundary edges outwards to complete the rough shape of the face (Fig.19).

Step 18

To complete the face, extrude the eye socket boundary inwards to encompass the upper and lower eyelids, which consist of all continuous edge loops, until hitting the eye. From here, extrude inwards again to give the eye socket some depth and finally merge all of the edges into one vertex (Fig.20).

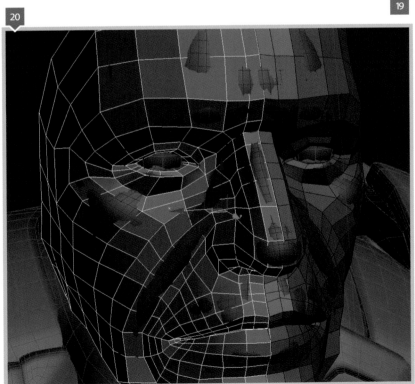

Step**19**

Move on to the character's right shoulder pad. Much like the base model and the sculpt, you are only going to work on one half and will just mirror that half over in the Y axis. Begin by removing unwanted edges (mainly those running down the inner portion of the shoulder pad and the indent we previously created at the center of the pad) (Fig.21).

Step**20**

With the indent gone you can bridge the top and bottom edges of the shoulder pad to fill the gap (Fig.22). I like to leave a slight bevel when I can, to get a better Normal map bake, though for the most part any small bevels and indentations have been removed from the low poly model and will be handled in the Normal map.

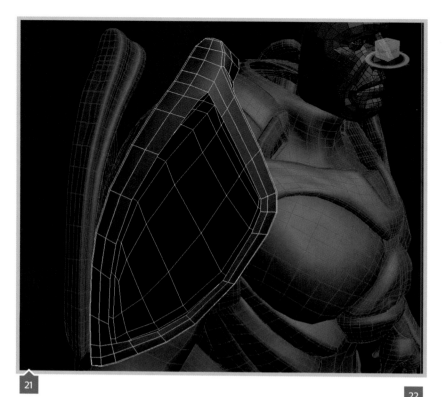

Step21

With one half complete, mirror it to the Y axis. These two halves will always be duplicates. The intention is to only unwrap and texture one half, which will be common practice throughout the character, excluding the face and torso (Fig.23).

Step22

From here move on to the forearm plates. Unlike the sculpt, the game version of this section will be one solid mesh rather than three separate ones (Fig.24).

Step23

As in the previous sections, begin by reducing the mesh as much as you can while still retaining the same basic shape of our sculpt. Since this is a fairly rounded object, terminate a lot of the edge loops inside of the armor plate to keep it budget-friendly and still have that nice smooth result (Fig.25).

Step24

Once the basic shape of the plate is complete, extrude edges on either side and begin building out the smaller plates that conform more to the wrists (Fig.26).

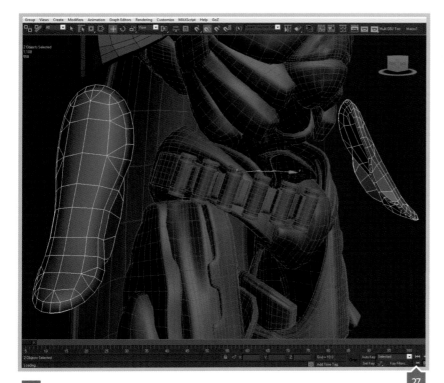

Step25

After the side panels have been created for the forearm plates, mirror the model in the X axis. Even though these objects will all remain duplicates – as in they will share the same UV space and textures – I still like to have them in the scene as I continue to work, as it helps give a better idea of how high my triangle count is getting (Fig.27).

Step26

Moving on to the character's left shoulder pad, we will be using the same technique as we did on the right shoulder, except for the fact that this one has a panel running down the middle that will be handled as a separate element in the model (Fig.28).

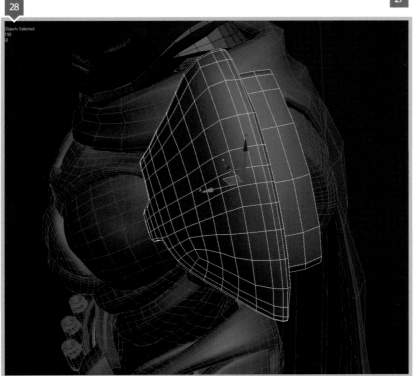

Step**27**

Simply remove edges and try to devote as many edges as you can to keeping the silhouette of the sculpt and retaining that nice smooth profile you had in the high resolution version. Once one half is complete, mirror it in the Y axis to complete the shoulder pad (Fig.29).

Step**28**

The character's cape is fairly straightforward. Remove any depth in the model and keep the outer shell, then remove a few unneeded edges. Something to keep in mind for cloth like this, when using spine bones to control deformation or in game cloth simulation, is that the edges need to be as evenly distributed as possible to avoid stretching. If this model was not deforming so freely, it probably could have been created with half of the triangles (Fig.30).

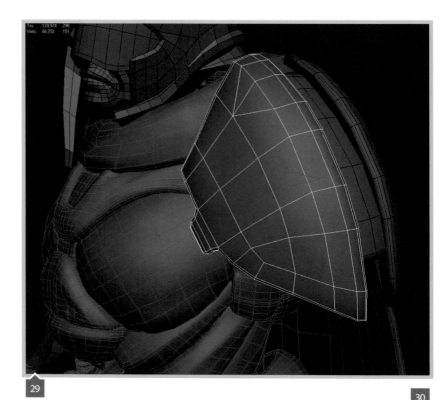

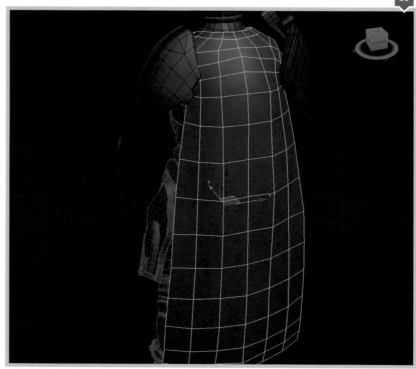

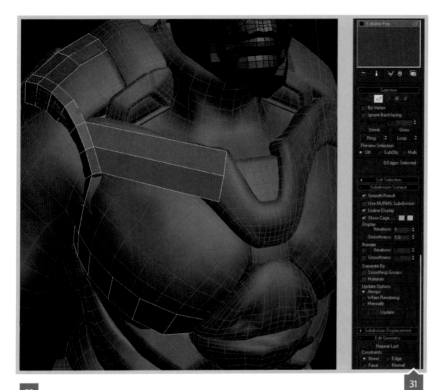

Step29

Move on to the chest piece and, ultimately, the beginning of the entire upper torso. Line the trapezius and pectoral areas with an edge ring and build out from there, marking the collar bone section and lower breastplate (Fig.31).

Step30

From here it is a matter of blocking out the bigger forms from our high resolution model and connecting them with edges, checking our base model as a guide. Focus on the forms of the collarbone, sternum and breastplate, allowing things like seams, bolts and holes to be handled in the Normal map. As you can see in my images I am staying fairly true to the high resolution model, just with simplified geometry (Fig.32).

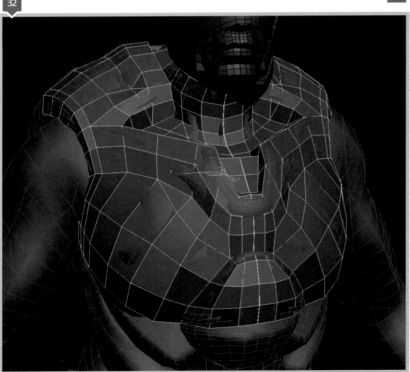

Step**31**

With the chest section of the armor complete, build downwards to include a simplified version of the rib pads, the lower portion of the sternum protector and finally the organic section of the stomach under the armor (Fig.33).

Step**32**

The midsection of the armor is composed of an organic material like rubber and will be where the character deforms most. There will be very little twisting done by this character, so leaving this section unarmored will help with movement. Add a few edge loops circling from the stomach to the back (Fig.34).

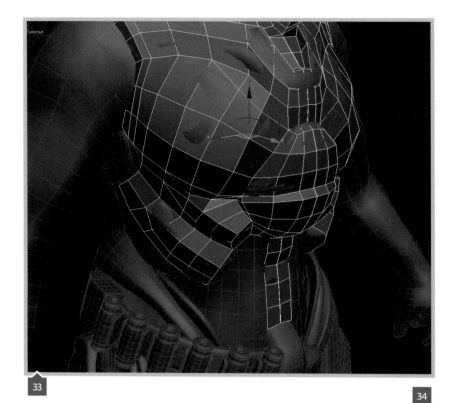

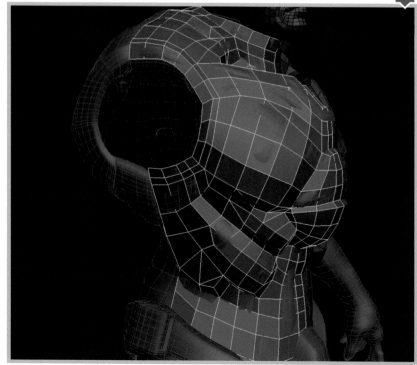

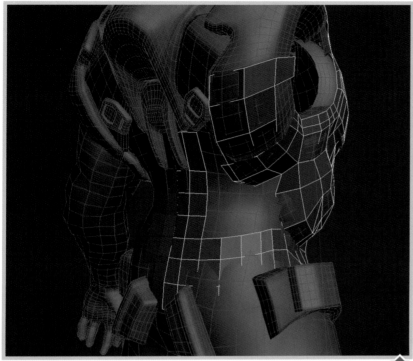

Step**33**

Continuing on to the back of our character, build outwards from the waist and armpit to begin forming the basic shape of the spine and shoulder blade armor sections (Fig.35).

Step**34**

With the major landmarks created for the back armor it's fairly easy to go in and trace where edges need to be dropped down. Focusing on the major shapes, like the shoulder blades and back pack sections, we can lay down their shape and fill in areas with bridged edges.

Add the hexagon tabs and the tabs connecting to the under-armor near the spine. These are mainly just for visual interest. If LOD models (lower resolution models that replace the base model at different distances from the in-game camera) were created, details like this could be removed (Fig.36).

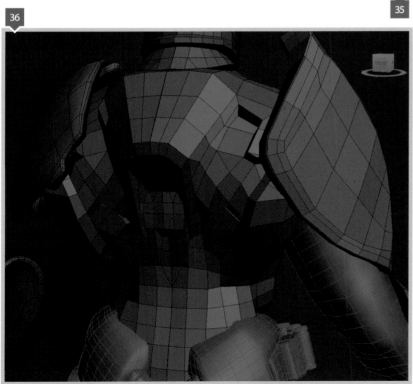

Step**35**

Next, move on to the arm. The ribbing details you created in the high resolution version are gone and you can easily create the bulk of our low resolution version by removing many of the edges. I like to leave a few loops around the character's elbows to retain shape during deformations (Fig.37).

Step**36**

For the hands, remove the fingers and begin rebuilding them with edge extrusions from the palm. It's less time-consuming this way, as you essentially just need to extrude the edge to each knuckle and continue on to the next. For each knuckle, bevel the top edges and terminate them in a triangle on the side of the finger. This helps keep the final triangle count low and will be good for deformations as the single edge at the back of the knuckle will collapse, while the two edges on the top of the knuckle will retain the shape (Fig.38).

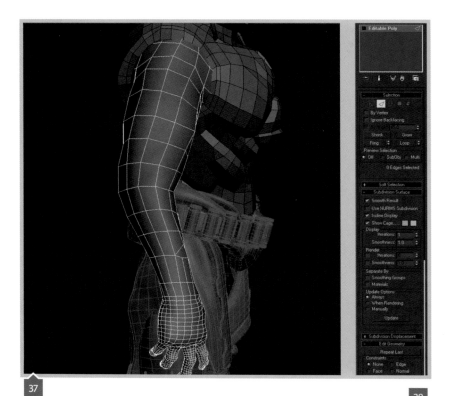

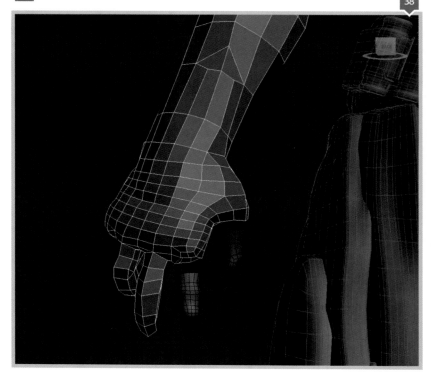

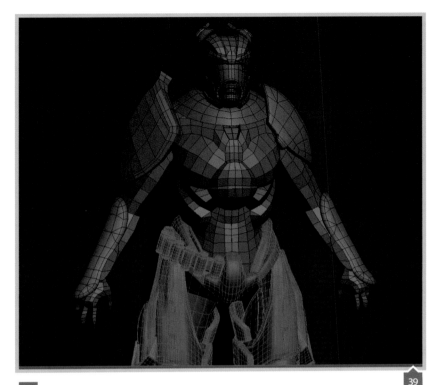

39

40

Step37

With the fingers complete, reduce the hand geometry by removing a few edge rings and mirror the entire arm on the X axis (Fig.39).

Step38

Next, move on to the armored codpiece. For this piece of armor I have simply created a plane and modeled it from scratch using the base model as a guide (Fig.40).

Step**39**

Moving on to the belt, simply remove a few horizontal edges from the base model and that's it. The grenades, on the other hand, take a little more work. To begin, extract the top ring on the grenade closest to the codpiece and extrude the boundary downwards to cover the entire grenade shape, leaving two horizontal edges to mark the extruded tab (Fig.41).

Step**40**

Next grab some faces from the center edge ring and extrude them to cover the tabbed section in the high resolution model. Bevel the top and bottom edges of the grenade so their profile is softer. On an LOD model these details would probably be among the first to be reduced, but since this model is mostly regarded as a portfolio piece this luxury will make the final presentation slightly better.

As you can see, all of the grenades are instances of the original one, which is closest to the codpiece. They will remain this way until the end to save UV space. When the time comes to bake Normal and Ambient Occlusion maps, simply use the original grenade and all of the information gathered from that will be carried over to the duplicate grenades (Fig.42).

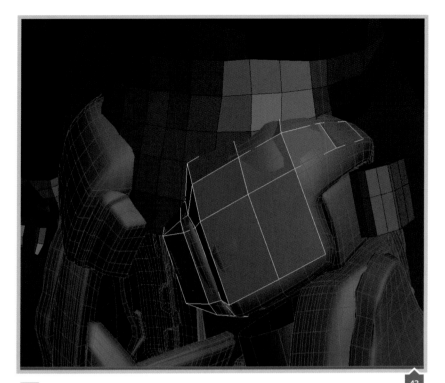

Step41

Move on to the hip armor and begin by blocking out the larger panel on the buttocks section of the character. It is important here to mark the edges of the large bevels in the high resolution model, specifically towards the character's rib cage, as we will need to continue these edges to the front of the character (Fig.43).

Step42

Continue the edges from the back panel towards the front, following the strong edges of the wider bevels created in the high resolution model. At this stage you can begin to mark the "hole" that reveals the character's under-armor, as well as the inner hip panel that would represent the character's pelvis (Fig.44).

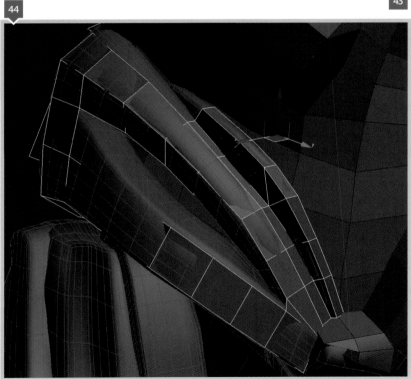

Step**43**

In Fig.45 you can see the completed model, which is one continuous mesh. Merge it into the codpiece armor as it will be easier to handle this during the weighting and rigging process.

Step**44**

For the floating leg armor panels on the character's thighs, remove the edges that you no longer need. Do this by marking the far corners of the model and the extrusion at the center of the armor panel (Fig.46).

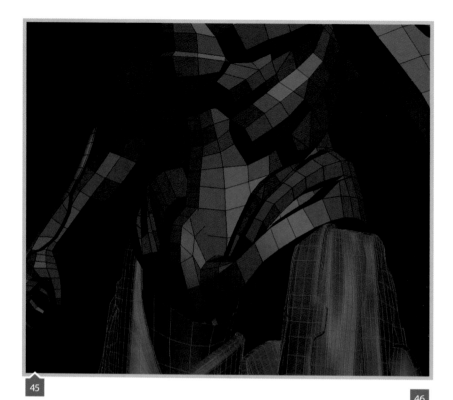

45

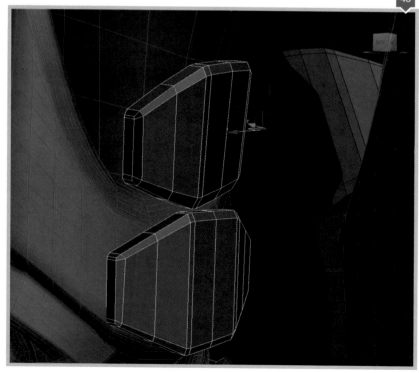

46

Step45

Next, move on to the upper leg armor. Although this was a complicated model in the high resolution version, it is made much easier in the low poly version as we can practically trace the outer boundaries and work from there. To retain the shape of the knee pad rim, simply remove edges from the base model (Fig.47).

Step46

The entire upper leg section is going to consist of one model, with the knee section being separate, as well as the shin and then the foot armor sections. For the upper leg it is important to lay out the bigger shapes we achieved in the high resolution version, such as the outer limits of the leg armor that circles around the leg itself and the dome object on the outside of the leg. Once these are laid out, build up towards the character's crotch by marking out the character's thighs using the base model as a guide (Fig.48).

Step**47**

For the angular brackets on the outer leg armor, make them as separate objects as it is easier to handle them that way. Create them by removing unnecessary edges and by retaining the far corners of the model to keep that nice rigid shape we had in the high resolution version of the model (Fig.49).

Step**48**

Next is the lower leg armor. Due to the nature of the high resolution model, we can use the shin as an anchor point of the model, but will need to build out each side as the panels are slightly askew. Build out the shin pad and work from there, starting with the right side of the lower leg, marking the extreme points of the model, which you can begin to fill in (Fig.50).

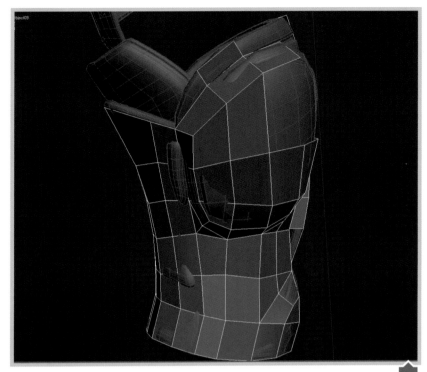

Step49

From here move on to the simpler, opposite side of the lower leg. The key element here is the plate that protects the calf muscle, otherwise the model is fairly straightforward and cylindrical (Fig.51).

Step50

Bring it all together and bridge the two halves. Cap the top of the lower leg armor by extruding all of the edges in, making sure to build the back faces of the top of the shin plate, and merging them down to just one vertex. Also add support edges where needed, like where the top of the second panel will be, to help keep the model profile the same as the high resolution version (Fig.52).

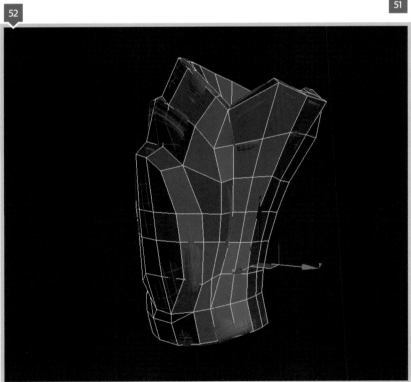

Step**51**

For the midsection that makes up the knee and leg under-armor, take the base model of the leg, remove the faces that will always be covered by the armor plates and extrude some of the faces, pushing and pulling vertices to match where the knee pad armor will be. This section will also need to be able to deform when the leg bends, so make sure you have a few loops circling the entire leg near the knee to support this (Fig.53).

Step**52**

To finish off the character, extract a few faces from the boot itself to begin building out from there, incorporating elements like the armor at the top of the foot and the nubs on the side of the foot that add some visual interest. Keep areas like this fairly low frequency in detail as it is an area that isn't usually seen by the player of a video game or, at the very least, focused on. The final triangle count for the character, including the cape and grenades, is 16,202. This is a touch high, but given the nature of this character I feel that it is acceptable (Fig.54).

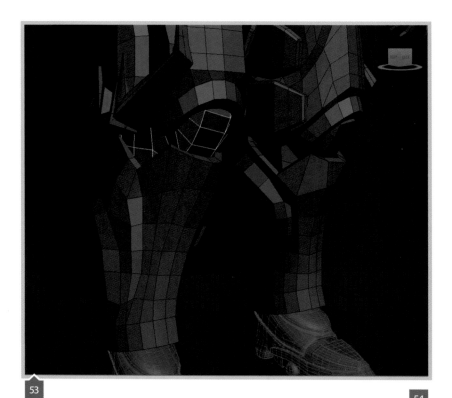

53

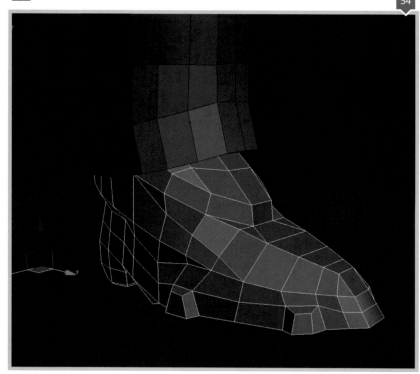

54

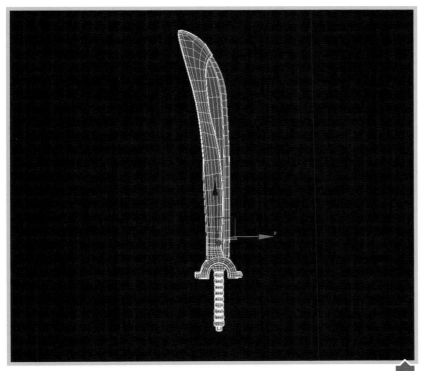

55

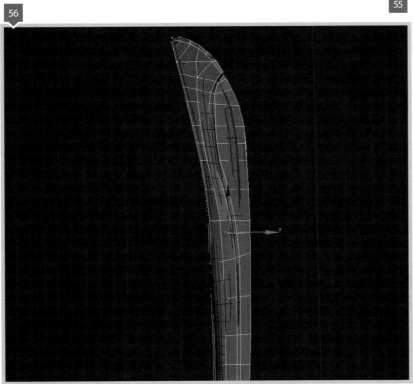

56

Step 53

Moving on to the character's sword, begin as you did with the character itself. Import the lowest subdivision from ZBrush so you have a pretty solid starting point for your low resolution model. You have to think of the weapons as if they are simply character accessories that could be swapped in and out or upgraded along the way. This means lower triangle counts and both weapons occupying one texture sheet. If these were intended to be first person weapons, the budgets would be a bit higher (Fig.55).

The entire blade of the sword will be one solid mesh. The actual blades – the parts that would do the cutting – will more or less be simplified down to a box (a plane on each side and connected down the middle with a face) with the outer side of the sword retaining its thickness and the nice smooth curve we created to give the model some visual interest (Fig.56).

Step54

The handle for the sword (which will most likely be hidden by the character's hand) is a simple cylinder that fans out towards the top and incorporates the metallic cap towards the bottom (Fig.57).

Step55

For the circular hilt take the top portion and reduce the edges significantly, grabbing some of the inner faces and extruding them outwards to create the same layering effect we have in our high resolution model. The connector between the hilt and handle is just a reduced version of the original, removing any bevels and keeping the shape fairly simple, but still achieving the same rough shape we have in our sculpt. The final triangle count for the sword is 996 triangles (Fig.58).

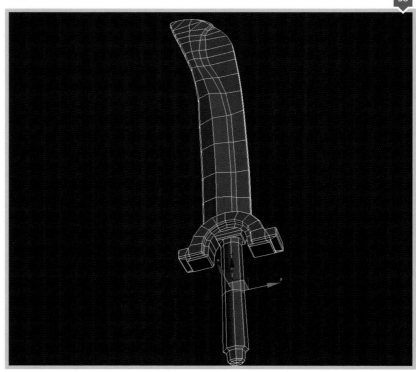

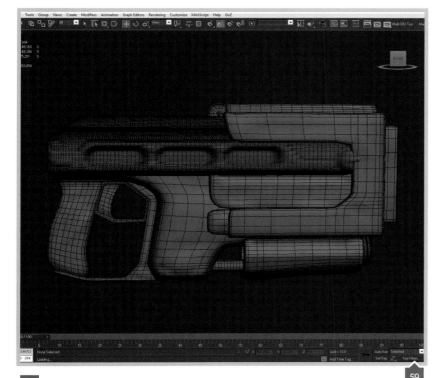

59

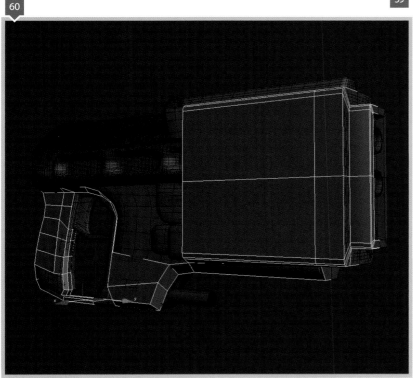

60

Step56

Finally, move on to the character's gun. As with the sword and the character itself, bring in the lowest subdivisions from ZBrush (Fig.59).

Step57

For most of the gun you can grab the front bracket of the gun, reduce its edges and build out from there, more or less creating the rough shape of the gun. Much like the sword, and to a certain extent many elements of the character, the gun doesn't need to deform. The key thing to keep in mind is how the low poly version will bake using the high resolution version as a target, while keeping the overall triangle count at a minimum (Fig.60).

Step**58**

After blocking in the body of the gun, cut in a few edges and begin to build in the rough shape of the gun's inner panels (Fig.61).

Step**59**

Most of the gun is more or less on the same plane of depth, though the holes towards the top of the gun are fairly deep and need geometry to support them. To keep everything even create one hole and duplicate the model twice, positioning each one to line up with the high resolution version (Fig.62).

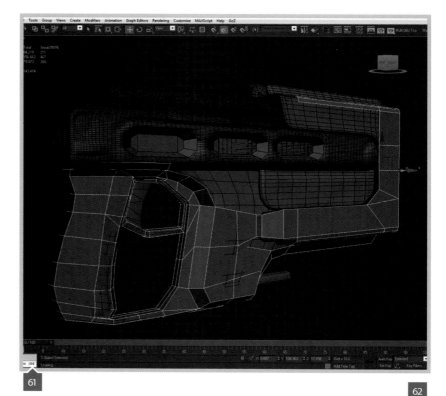

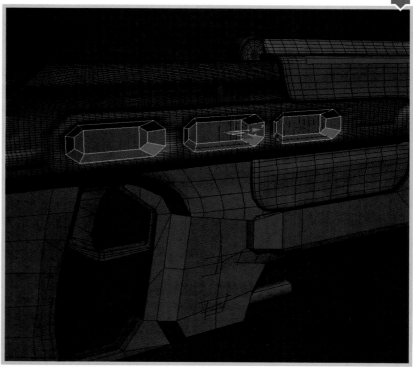

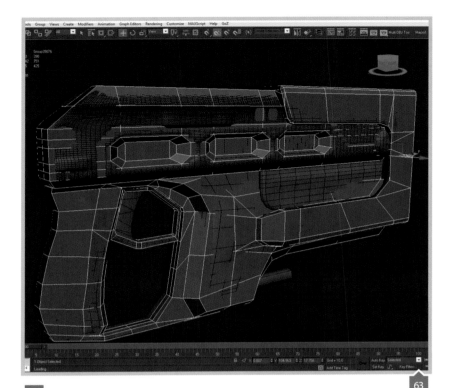

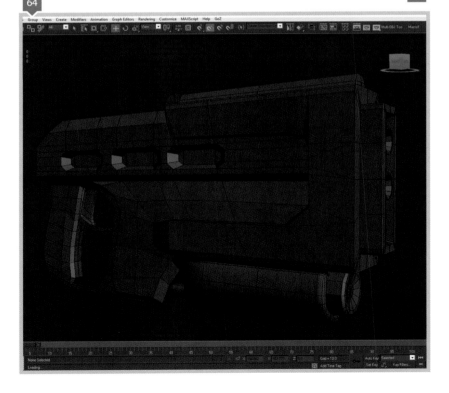

Step**60**

Next, build out the rest of the gun by bridging these landmarks together. To help catch light and again, be slightly more visually interesting for display, retain the definition between the inner and outer panels of the gun (Fig.63).

Step**61**

To finish off the character's gun, remove many of the edges from the front grip and create the rails and top cylinder by removing faces and edges that add nothing to the gun's silhouette. The final triangle count for the gun is 2,301 (Fig.64).

Sidebar**Tip**: Grayboxing

A common practice in a professional environment is to take a rough version of your character, have it quickly weighted to the rig that your team will be using for animations and drop it into the game. You can also make dummy textures that will then be loaded into the game as a placeholder for what the final product will be. From here, even without real textures, you will be able to see how the silhouette of the character reads in the game as well as get a rough idea about how it will look in motion. You can also see the character's common viewing angles and get a rough idea of what the final memory footprint will be for this asset once it is completed.

Though this may seem like a tedious task, it can save you time in the long run as it lets you know for sure that the asset will work before you spend days on a texture and material pass. Better safe than sorry!

CHAPTER**FOUR**
UV UNWRAPPING

Introduction

In this chapter we will be covering the creation of a UV map for our character. A nice clean unwrap is usually an overlooked part of the process that is extremely important to our final product. With a well laid out UV map you can benefit from texture resolution and cleaner texture bakes when creating Normal and Ambient Occlusion maps.

Step01

To begin, analyze which parts of the low poly mesh can be unwrapped once and mirrored for optimal UVs. In earlier steps we also covered instancing objects for this reason, such as the bullets and shoulder pad panels. In an ideal world everything would be unique and have finer details to create asymmetrical detail, but given modern day standards it is wise to mirror sections that will not be focus points and leave asymmetrical detail to larger, iconic pieces. For this character I recommend mirroring the limbs, half of the shoulder pads and the helmet, leaving the chest and face as fully unique objects (Fig.01).

Step02

Next create a standard material and assign a checkerboard pattern texture to the Diffuse slot. Using a checker pattern is a great way to make sure that all of the elements in your UV map are taking up the

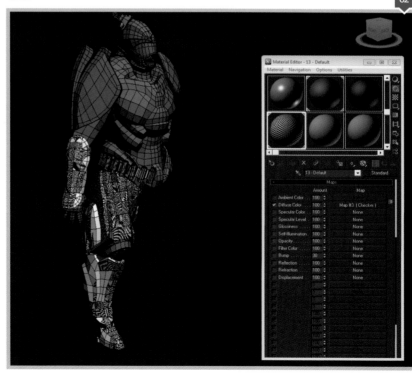

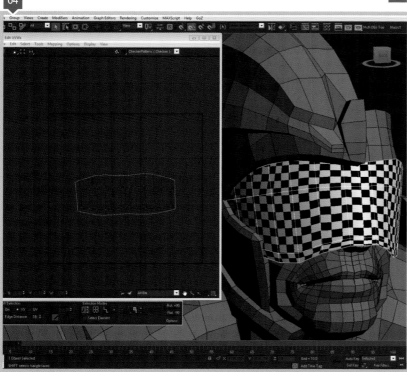

correct amount of space. For example, seeing many tiny squares on the chest and only a few large squares on the arm will tell you that you need to devote more UV space to the arm, or less to the chest, to make them equal. This is important when texturing as you will want an even texel density along the mesh to make sure details are at the same scale.

In 3ds Max press M to bring up the Material Editor. Select a shader ball and navigate to the Diffuse texture slot. Click on the button to the left and select Checker from the list. Once this is done various properties will be available to you so that you can alter the checker's appearance. I usually just stick with the normal black and white checkers and set the tiling to 25 x 25. Having more checkers visible to you just makes it easier to visualize the real estate each piece of the mesh is taking up, and having equal U and V tiles ensures that the checkers will be square. Once the shader is set up, select all of the objects in the scene and assign the new checker material to them (Fig.02).

Step03

Grab the visor and apply an Unwrap UVW modifier to it. This will be a constant step throughout the entire tutorial as 3ds Max requires a modifier to access the model's UV information. Once this has been applied, enter Edit mode, select all of the faces and assign a simple Planar map. Based on the appearance of the checkers you can see that there will be some distortion along the edges of the visor. In the UV Editor, grab these UVs and pull them left or right. Make sure that Constant Update (located in Options) is enabled to immediately see these changes in real-time (Fig.03 – 04).

Step04

Up next is the face. After applying the modifier, grab all of the faces and assign a simple planar projection to the model. This will cause some significant distortion towards the edge of the face and the sides of the nose, but it will give us a solid starting point (Fig.05).

Step05

Apply a Pelt map to the model. This will be based off of the boundaries that we have already set in the previous step as Pelt maps are general UV island based. If the initial result isn't perfect, no worries; select the UVs that you would like to adjust, even if it is all of them, and apply Relax (located in Tools > Relax in the UV Editor). This will average out the space between UVs and save a lot of tedious work by eliminating the need to adjust each UV manually (Fig.06).

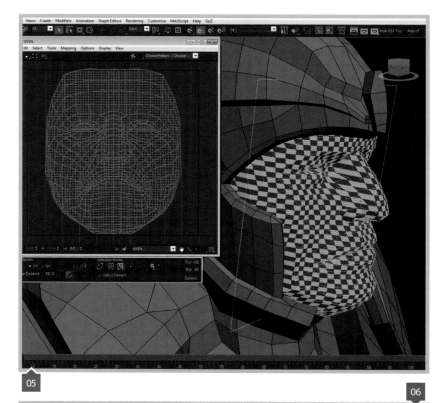

05

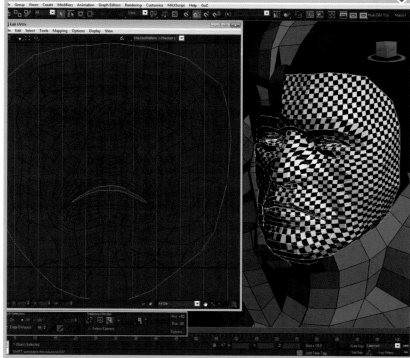

06

Step06

Since we have split the helmet down the middle, unwrapping it is fairly easy. By applying a Pelt map to the model and relaxing a few of the trouble areas, we get a fairly clean and easy to read image of our helmet's shell (Fig.07).

Step07

The helmet's antennas are a bit more complicated as there are extrusions that simply can't be connected to the main UV island. This is a good example of the need to find natural UV seams in your model that will be hidden from the viewer and/or easy to paint over in the texturing process. To start it off, select all of the faces in the base of the antenna and apply a Planar map. Grab all of the unrelated faces, the ones belonging to the antenna itself, and move them aside (Fig.08).

Step08

From here, either relax the UVs of the island or grab the outer edge UVs, expand the selection scale, shrink the selection each time and repeat the process. This is a manual way of spreading out the UVs and making sure the original shape of the island remains intact (Fig.09).

Step09

To finish the helmet grab the face of each plane on the antenna and apply a planar projection to each one. This should give four UV islands. Next, weld the UVs on the boundaries together, leaving a seam at the bottom of the antenna. Once all of the islands have been merged into one, straighten out the UVs horizontally and vertically. Do this where possible to help save on UV space (irregular shapes can be harder to manage and squeeze into the map) and to assist when texturing as it is generally easier to paint on straight shapes than curves (Fig.10).

09

10

Step10

Next we will tackle the torso. At this stage split the body down the middle, unwrap half of it, mirror a duplicate of the model and stitch it together. In my case I have decided to leave the main seam of the torso running down the back as it will usually be covered by the character's cape and is generally easy to paint over. Grab all of the faces and apply a planar projection. This will cause a lot of the faces to overlap as it will be assigning a projection to the front and back of the model, which will overlap on the same plane. Once this is done, grab the faces that make up the back and detach them from the main island, moving the new island off to the side (Fig.11).

Step11

There is a lot of distortion along the side of the character, so grab most of the faces on the rib cage and apply another planar projection that will break these UVs off from the main island and give them a cleaner unwrap (Fig.12).

Step**12**

Next line up the rib cage plane as best as possible to the chest and stomach sections. Once you are happy with the positioning, weld the boundaries together and this will result in one island again. I find this method to be less confusing and time-consuming than pulling out each UV individually. If the UVs have become too distorted or if there are overlaps, don't hesitate to grab the UVs and relax them (Fig.13).

Step**13**

Once you are happy with the chest you basically need to repeat the process for the back section by creating a plane near the oblique and welding them to the main back island. Also tweak the shoulders manually, pulling the UVs out from the main island for less distortion. After both halves are looking good, weld them together along the side of the character and relax any UVs that might be causing problems.

Next collapse the Unwrap UVW modifier and mirror the model. It is important here to just duplicate the model and not instance it as you will be flipping the UVs on the new model. After you flip the UVs, merge the models together, welding the geometry down the front and back. Once the model is complete, access the UVs again and weld the UV islands down the chest (Fig.14).

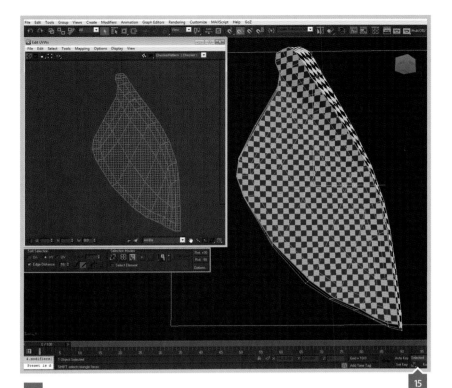

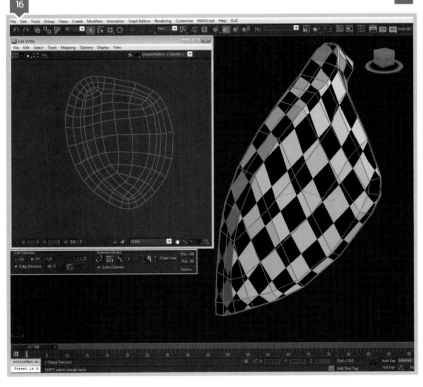

Step 14

Moving on to the shoulder pads, grab the underside of one half and apply a planar projection. To me, areas like this are an exception to the rule. This is because the geometry only exists to give the model depth and most likely will never be seen or will be very hard to spot. For those reasons these sections would be the first to get less pixels devoted to them in the unwrap, as they will most likely be a solid or a near solid color (Fig.15).

Step 15

Next grab the remaining faces and Pelt map the island. Because we have a well-defined UV boundary the result should be a fairly clean, oval-type shape. If needed you can relax some UVs or manually push out the outer edges (Fig.16).

Step**16**

Moving over to the left shoulder pad, you basically repeat the process. First, break off the underside of the shoulder pad and Pelt map the top half, relaxing or manually tweaking problem areas to fix texture distortion (Fig.17).

Step**17**

The dividing panel between the halves of the left shoulder pad is fairly easy to handle. Simply apply a planar projection and adjust the top and bottom UVs for more even pixel distribution (Fig.18).

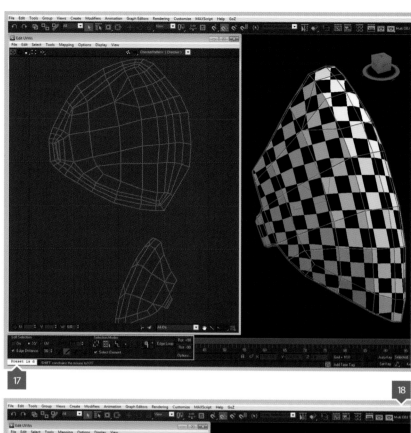

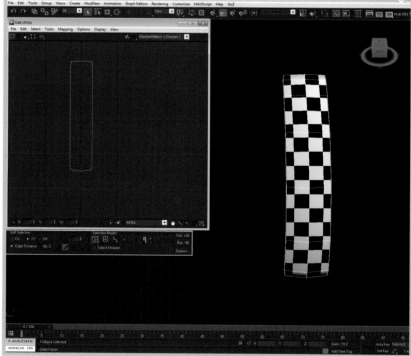

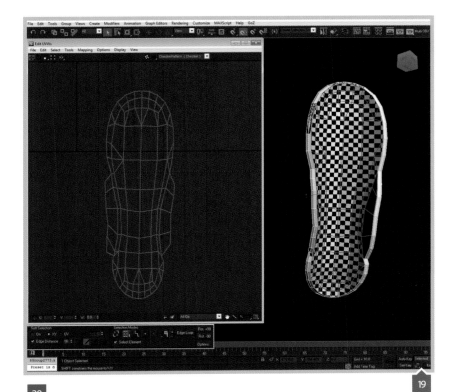

Step 18

For the forearm armor it is more or less the same situation as the shoulder pads. To begin, grab the underside and apply a simple Planar map. Because the tabs of the forearm armor are connected, they may need to be manually adjusted (Fig.19).

Step 19

Next apply a Pelt map to the top side of the armor plate and relax or manually adjust the UVs where needed (Fig.20).

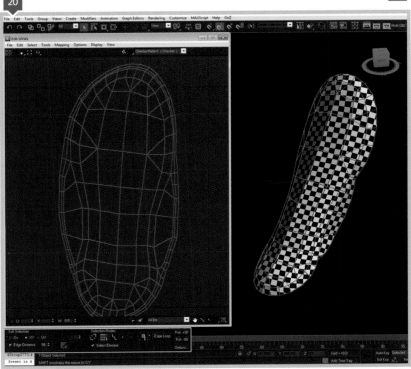

Step**20**

The cape is fairly easy to take care of. Simply make two planar islands, one for the flap covering the back and one for the ring that goes around the shoulders. Once this is done grab both islands and weld their UVs together. Since the cape has a slight flare don't bother straightening out the edges as it could cause the cape's UVs to become distorted (Fig.21).

Step**21**

Up next is the belt. This is a pretty simple planar object. Take the time to straighten out the vertical and horizontal edges, again to make the UVs easier to pack in the final map and to make the object easier to read in 2D space. Weld the back of the belt to the main island to avoid a seam on the top of the belt (Fig.22).

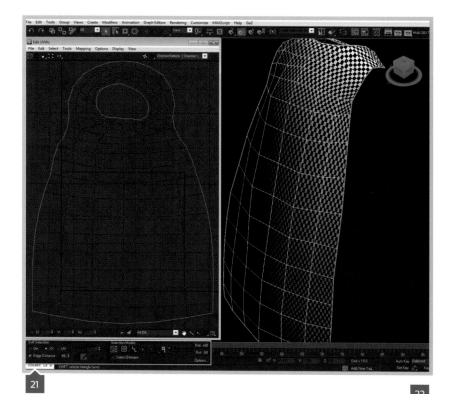

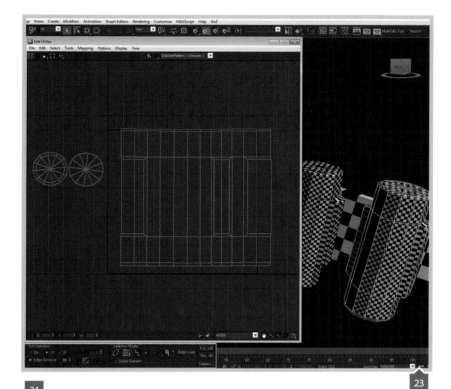

Step22

For the ammo apply a cylindrical projection to just one of them and rotate/move the projection controller as needed to get the final result, which should leave the UV seam at the back of the ammo. Also split the top and bottom off into planar projections, but don't bother welding them to the main island as only one edge would be welded, leaving the rest exposed, and it is easier to manage one rectangle and two circles than it is one larger awkward shape. You'll notice that by changing the UVs of one ammo model, all of them should be updated due to the fact that they are instanced copies (Fig.23).

Step23

For the belt clip apply a planar projection to each piece and weld them together, following the path of least resistance. In my case I choose to have a seam on the top and bottom of the model over the distortion created by compensating for the curve in the geometry (Fig.24).

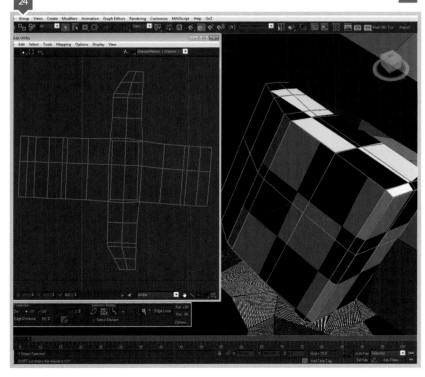

Step**24**

The pelvis armor is similar to the torso piece we covered earlier. Split the model in half and apply planar projections to the front, side and back. You may have to do some clean-up work to spread out the underside of the armor as well as the hole in between layers on the side of the character. Once this is done, duplicate the model, mirror it, flip the new model's UVs and merge the models together, welding the geometry at the crotch. Once this is done, weld the front UVs in the editor and relax the UVs where needed (Fig.25).

Step**25**

Moving on to the leg armor, assign a cylindrical projection to the model. After adjusting the projection to make the seam on the inner leg, you'll notice that the seam is fairly jagged and not clean at all. However, this is a very strong starting point for our leg, especially considering that the outer leg only needs some minor clean-up work (Fig.26).

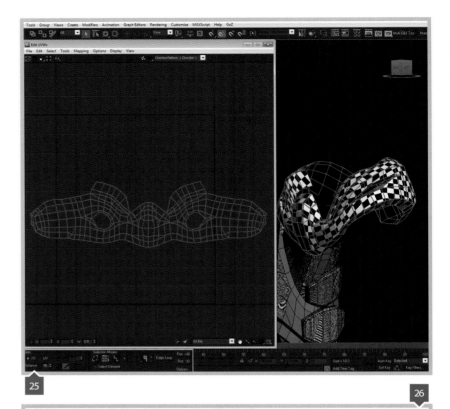

25

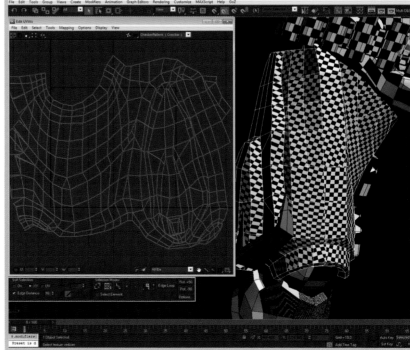

26

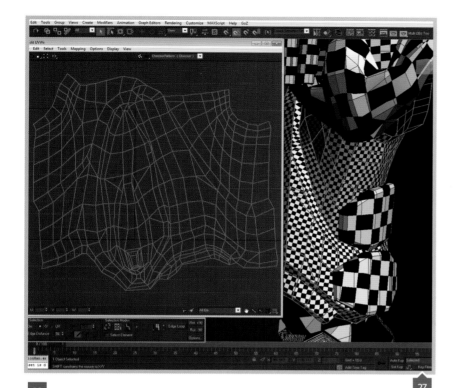

27

Step26

Next grab the strips making up the inner leg seam and apply planar projections to them. Then weld them to the main island we previously created and begin, relaxing and tweaking UVs to make the layout as clean as possible (Fig.27).

Step27

Once the leg UV unwrap is looking good, move onto the angular pieces that are separate geometry elements of the leg armor. These pieces are a little tough to get right and will take some massaging. Do a planar projection and manually pull out the UVs as using pelt on this sort of complicated object can lead to weird results that don't resemble the actual model (Fig.28).

28

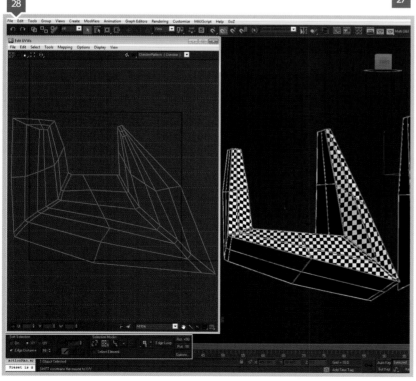

Step**28**

Repeat the process for the other half of the angular details. The shapes are not symmetrical so you don't need to unwrap each one as a unique object (Fig.29).

Step**29**

For the knee area, which is our organic element that will enable us to bend the leg naturally, use a simple cylindrical projection, favoring the inner leg for a seam location (Fig.30).

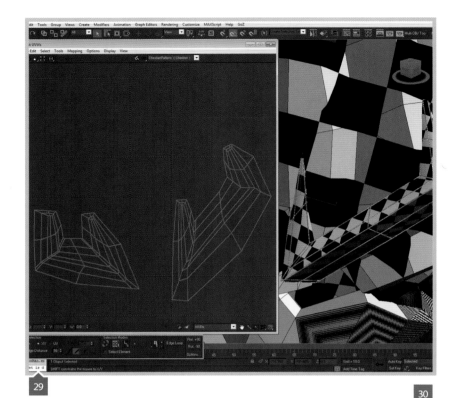

29

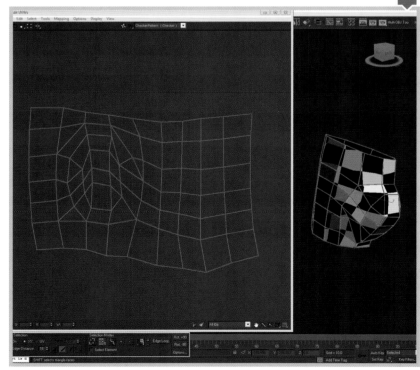

30

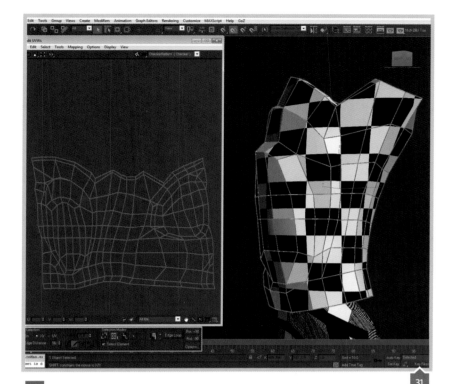

Step30

Next up is the lower leg armor. Follow the same technique as in the earlier steps. Analyze the mesh and determine how to break it up by planes and where to leave the UV seam. Split the mesh into three planes, basically the front and two sides, leaving the seam towards the back of the calves where the armor plates meet (Fig.31).

Step31

Moving on to the boot model, first grab the bottom of the foot and give it a planar projection. This helps split these UVs off from the main island of UVs that we will be working with, and since the bottom of a character's feet are rarely seen, can be given less real estate if needed (Fig.32).

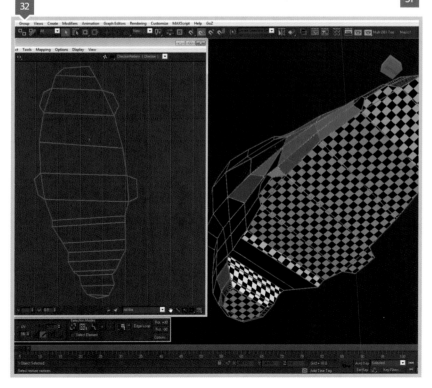

Step**32**

Next grab the top side of the foot and apply a planar projection, which essentially splits the model in half. Grab the two halves, which should consist of the left and right side of the foot, with a seam running down the back, and apply a Pelt map to each one. The sides are not identical, so the result will be similar but have some small differences (Fig.33).

Step**33**

Once you are happy with all three elements, weld the top side of the foot to both halves, and leave the seam of the foot near the sole and at the back of the boot near the ankle (Fig.34).

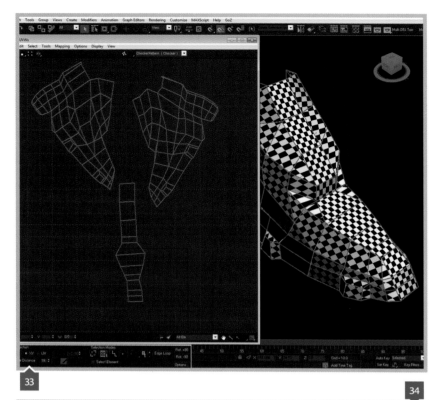

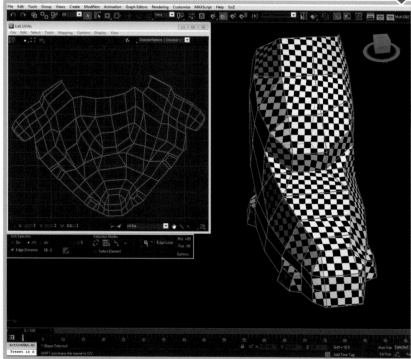

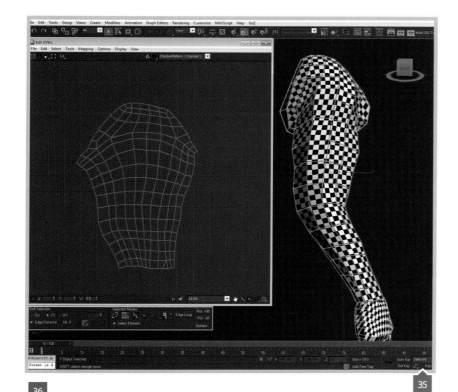

Step 34

Moving over to the arm and hand, grab the faces that will make up the arm, splitting the two at the wrist. With these faces selected in the UV Editor, detach them and apply a cylindrical projection, leaving the seam on the underside of the arm as this will rarely be seen and will be mostly covered by armor plates (Fig.35).

Step 35

Next split the finger and thumb UVs from the hand and move them aside. Grab the top of the hand and apply a planar projection. Do the same for the palm and weld the two halves together at the bottom of the hand, leaving the seam at the forefinger and thumb. Once this is done, weld this new island to the arm at the wrist UVs (Fig.36).

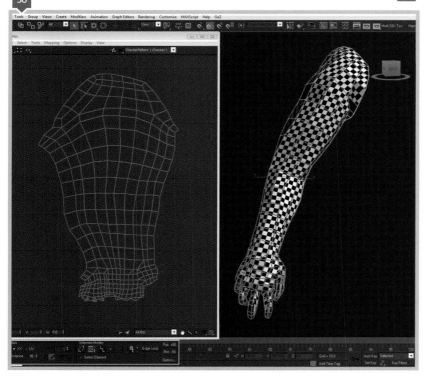

Step**36**

Next, tackle each finger individually. Apply a planar projection to the underside then spread out the UVs manually for the topside islands. Once you are happy with their layout, weld them to the main island consisting of the hand and arm (Fig.37).

Step**37**

Finally merge the models together, access their UVs, and begin organizing all of the islands into the working 1:1 region of the UV Editor. There is no hard and fast rule as to how things are laid out, other than trying to keep the density of each piece equal. Try to line up elements as they are in 3D space so that they can be easily read. A good example of this is the positioning of the leg armor pieces being next to each other and the pelvis being located under the torso (Fig.38 – 39).

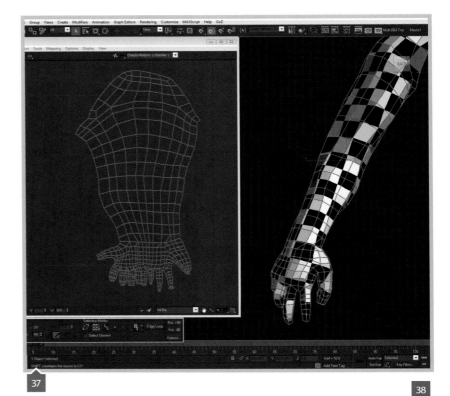

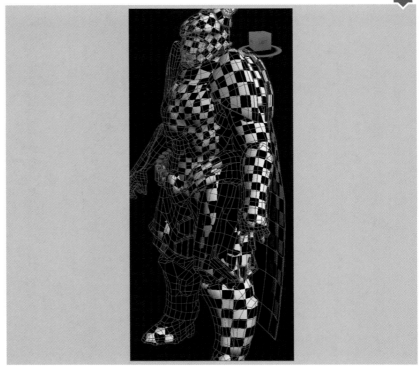

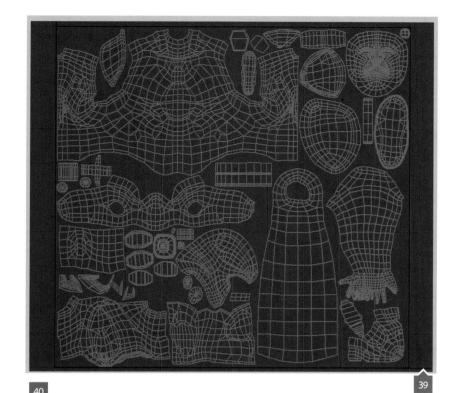

39

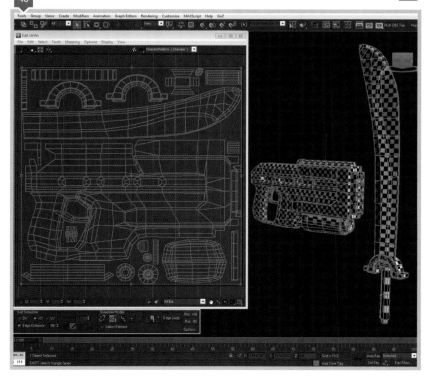

40

Step**38**

Unwrapping the weapons is fairly straightforward. Start by putting them on a separate sheet, as in the game they may need to be swapped out for other models, need different effects or have different limitations on them, and doing this allows for better asset management. For the most part, split each weapon down the middle, like the helmet, and modify a planar projection to try and keep the UVs as solid islands (Fig.40).

Sidebar**Tip**: External Unwrapping Tools

A common way artists speed up their workflow is to use programs specifically made for unwrapping. Personally, I use the UV unwrapping feature of a free program called Wings 3D. I find that it is comparable to other popular alternatives and is a quick way to help Pelt map complex models and, at the very least, split up complicated models into sections that are easier to understand and work with. This is perfectly okay and to a certain degree expected in modern workflows; it really comes down to a matter of preference. The key thing to keep in mind is that the final result of your UV map should be easy to read and maintain a logical texel density throughout the entire model (e.g., no distortion or wasted space due to awkward shapes).

CHAPTER**FIVE**
TEXTURING

Introduction

In this chapter we will be covering the creation of texture maps commonly used in today's video games. From the baking of Normal and Ambient Occlusion maps to hand-painting diffuse textures and FX, a good texture can really make or break a game model. Too much detail can become distracting, too much baked-in lighting can nullify the benefits of Normal maps and too little contrast or too few points of interest can leave a model looking bland.

Step**01**

First off, begin analyzing which portions you can group together for your texture baking. For the most part you want to avoid one chunk influencing another chunk. For example, the upper and lower leg will be baked separately, since you do not want information on the high resolution version of the upper leg to be baked into and visible on the low resolution of the lower leg. The same example can be applied to the shoulder pads. Having information from the shoulder pads baked into the texture of the chest would lead to rendering errors.

It's also common practice to create an "exploded" version of your high and low resolution models to avoid the same issues. Both methods work fine, although I find it easier to just create multiple bakes and compile them in Photoshop (Fig.01).

Step**02**

For texture baking, I like to use xNormal. XNormal is a free application created by Santiago Orgaz (http://www.xnormal.net/1.aspx) that is made specifically

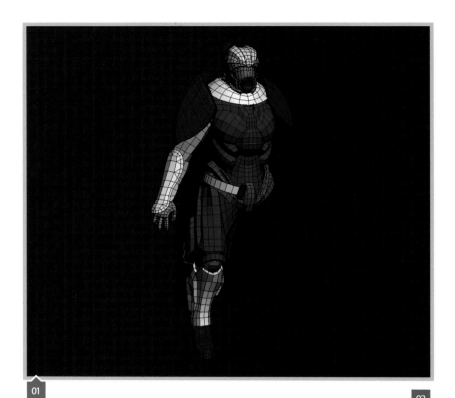

04

03

for baking maps of all types, or at least any type of map commonly used in the industry. Since there is no viewport, loading high resolution models into the program will practically not affect your machine and, since those rendering resources are not being used, your baking times will be reduced significantly.

After you install xNormal, open it up and navigate to the High Definition Meshes tab. This is where you will specify the high resolution target meshes that you have exported from ZBrush. To add meshes to the list, simply right-click over the cells and click Add Meshes. Generally, I add all of my meshes and use the checkbox to toggle their visibility. If it is easier, you can also add and remove meshes as needed instead (Fig.02).

Step03

Next, load in the low resolution model that was exported from 3ds Max. Much like before, navigate to the Low Definition Meshes tab, right-click over the cell and add the meshes that you would like to use. I often set the mesh normals to Average Normals for each model, which is essentially the same as having just one smoothing group on your entire model.

When it comes to baking, xNormal is essentially using a uniform ray cast rather than a cage (though a projection cage can be created and used, if needed, in an external program like Max using the SBM plugin provided with xNormal). This means that whatever value you enter for the ray cast limits, xNormal will search at that distance for information and bake it into the maps you have specified.

For each chunk that you export you will more or less bake out a set of maps (usually just Normal and Ambient Occlusion). Manage this through the checkboxes on the left and by toggling visibility on for related models. Once all of the maps are complete, compile them in Photoshop with the final result being one map of each type (Fig.03).

Step**04**

If you navigate to the Baking Options tab you will be able to specify where the maps will be saved to, as well as the dimensions of the Texture map. I tend to bake maps larger than needed in case the model will need to be used in a high resolution, like cinematic or print. In this case, I'm baking a square 2048 map, which is fairly standard.

Here you can also flag which types of map you would like to create, as well as the Anti-aliasing quality (which significantly increases rendering times) and edge padding. Edge padding is used to help textures mix properly and avoid texture seams when doing so, which is also why it is wise to leave some space between your UV islands. When everything is set to your liking, click Generate Maps. Once the preview finishes, your map is baked and ready to be used (Fig.04).

Step**05**

To view textures on my models, I use the Xoliul Shader 2.0. The Xoliul shader is a free, real-time shader created by Laurens Corjin and Robbert-Jan Brems (http://www. viewportshader.com).

After installing the shader, navigate to the Material Editor in 3ds Max and change the material type from Standard to Xoliul Shader (Fig.05).

Step**06**

Once the shader initializes, a custom user interface will appear in the Material Editor, which will provide you with a healthy suite of options including texture types, atmospherics and rendering techniques. Apply this material to your model and simply click on the appropriate texture type to navigate to your textures, then load them into the scene (Fig.06).

07

Step07

After compiling the different Normal maps together that have been baked using xNormal, use the alpha channel of each image as a mask to assist with preventing overlaps as some elements may bleed over on to another one, which will cause rendering problems. If trouble areas are spotted, like inaccurate bakes, you can either hand alter them in Photoshop using the Smudge tools or Standard brush, or simply create a new bake that is more tailored to that specific area (Fig.07).

Step08

Using the same method as the Normal map creation, gather all of the ambient occlusion textures together into one image. The ambient occlusion will initially be used as a guide for where to paint different materials. In the final product, the ambient occlusion texture will be used very subtly to help ground certain elements (Fig.08).

08

Step09

Once you are happy with how the Ambient Occlusion map looks, set its blending mode to Multiply and drop a neutral color underneath it. In this case, I have a layer of dark gray, which will more or less act as the base color for the Swordmaster character.

My approach for texturing is to work on all the areas at the same time so that the entire character progresses evenly. It can be distracting and, in some cases, problematic to only focus on small areas at a time as it can become hard to see the big picture. On personal work I find that I can actually lose steam as well if I spend too much time on one area and do not see enough progress overall (Fig.09).

Step10

If the renderer supports it, I like to use PSDs as my texture format as it saves time and confusion from saving from a PSD (which you are most likely using as a source file) to a flat image format like TGA or PNG. I also like to use a naming convention that has a shortened version of the map type as a suffix, for example: "swordmaster_DIFF" and "swordmaster_NORM."

To start off, just focus on the diffuse texture and Normal map information. However, it is a good idea to work on your Specular and/or Gloss maps at the same time before too much information gets baked into the diffuse texture that wouldn't necessarily change specular values. Once the maps are saved out, load them into the viewport shader to see the final result in 3D. If you spot any errors, manually touch them up or re-bake the information (Fig.10).

Step 11

Next, begin defining the different material types by lasso selecting the area or by painting with a hard brush at full opacity. At this stage, just focus on the bigger material changes, which are namely metal, rubber, flesh and fabric.

For the most part the materials on this character are pretty clean and simple. Most of the work in the diffuse texture will be breaking and popping armor plates off in interesting ways, such as outlining in black and slight color changes. In this case any noise in the texture should be handled in the Specular map as the surface material itself is clean/not destroyed, rusted and fairly streamlined. The Specular map will hold all of the imperfections in the surface that will be visible in different lighting conditions (Fig.11).

Step 12

Moving forward, start to define the smaller differences in material types within the metal plating. This really helps pop out plates from the surrounding area and, in this case, really helps add some points of interest. A good example of this is the metallic detailing along the arm's under-armor and the lighter metal against the darker surface of the chest (Fig.12).

Step**13**

Render out a rough UV map, invert it and set it to Multiply over the top of your texture. This just helps define the boundaries of each element, where you shouldn't paint and where the different regions are that you may have missed in the initial color blocking stage (Fig.13).

Step**14**

Next, distinguish the different material types within the armor. Once you get to this stage you can start to add some finer details such as painting in the knuckle plates and details on the boots. Keep these different material types on separate layers within your texture for easy selections, as well as to make your life easier in the future when you create your Specular map. For the most part, each material will have a different spec value, so not having them flattened into one layer will make it much easier to adjust (Fig.14).

Step 15

Next, begin painting crisp black lines on the seams of the armor and under-armor to help define each element. This detail will also be carried over to the Specular map to assist with the same goal by breaking specular highlights in between plates. Also begin to fill in the holes with black to imply more depth in the model (Fig.15).

Step 16

It is always a good idea to check your work regularly when working on a texture. Not only does it help you spot mistakes, I find that it helps encourage me to either try different approaches with my texturing or to keep pushing forward by watching the model slowly come to life as color is applied. The Xoliul Shader usually automatically updates when a file is saved. If it doesn't though, you can easily manually reload the texture (Fig.16).

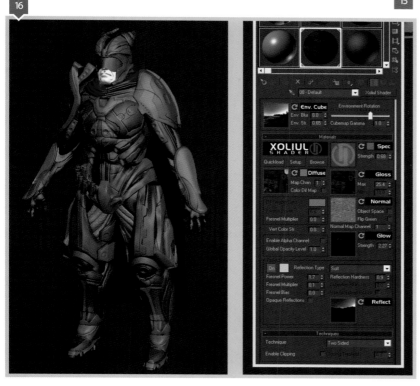

Step**17**

Continue to develop the finer details. At this stage you can add black lines to the finer seams, which are most noticeable on areas like the helmet and the chest armor. This serves the same purpose as in the previous step, just on a smaller scale. By pumping up these finer lines you really help sell the breaks in the material. The same sort of technique can be accomplished with a nice Cavity map as well, though I find Cavity maps can be too broad and a little unpredictable. For example, you may not want every crevice in your model to be exaggerated.

Also begin adding smaller color details to the model, such as smaller arrows that would be implying connection points and manufacturing details on the suit. I find this sort of detail helps ground the armor in reality by hinting that it is a product created for people (Fig.17).

Step**18**

Continue with the finer outline details and then move on to broader, gradient shadows in areas that will always be intersecting with another piece. I find that self-shadowing helps, though it is very easy to go overboard. The key here is to create subtle shadows and color differences that will help make the armor plates read better (Fig.18).

Step 19

Next, move on to the character's face. Usually I like to start off with a photo reference, bringing in sections from different angles of the human face and stitching them together in Photoshop. In this case, since the character's face really just consists of the front facing plane and not the entire head, it is fairly easy to bring in a front shot of a Caucasian male's face and line up the major elements using the Warp tool (Fig.19).

Step 20

Brighten up areas of the texture and continue making feathered selections on the elements that need to conform to the face better, such as the lips and the eyebrows, using the Warp tool. By having a feathered selection the blending is a lot less rigid and easier to work with (Fig.20).

Step**21**

In Fig.21 you can see that I have blurred the original image slightly using a Gaussian Blur filter, as well as smudging colors around to fit my model. From here you can also add some color correction layers, painting in reds where blood would be closer to the skin and blue tones where stubble may be. In general, I find that a more illustrative face is a better fit for a high tech, over-the-top kind of character like this one.

Once you are done with the face, go over the entire texture again to punch up any areas that need more attention.

Step**22**

When you are happy with the color blocking on the diffuse texture, begin working on your Specular map. First desaturate your diffuse texture and begin tweaking the brightness of each color to represent how glossy the area will be. In this case our specular color will be taken care of in the engine/model viewer with a grayscale image driving which parts of the texture are shiny and which parts are not. The tightness of the specular highlights will also be handled in the viewer programmatically, not by creating a texture (Fig.22).

21

22

Step 23

Continue tweaking the different values and try to focus on a nice contrast between the lighter metal sections and darker metal sections. The end goal will be to have the lighter metal representing chrome (Fig.23).

Step 24

At this stage begin dropping in subtle grunge maps taken from photo sources over the texture, to make the surface slightly imperfect. I find that having breaks in the surface texture within the Specular map helps sell the believability of the piece as the viewer will be able to see the fingerprints, scratches, dings and wear caused by use. Also bring in the black lines from the diffuse texture to help mark seams in the armor plates. As mentioned earlier, this will help break up the specular value along the model's surface and really make those armor plates pop out in the game render (Fig.24).

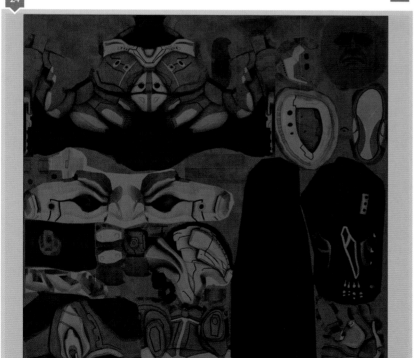

Step**25**

Next begin the subtle shading, add more lines and touch up the contrast throughout the entire texture (Fig.25).

Step**26**

You want the character's face to be fairly matte compared to the rest of the armor. Taking the diffuse texture information, desaturate the image and begin brightening and darkening the face. In general, areas that would have more oil collected in them will be brighter than the dryer areas, which will be darker. In this example you can see that the nose, lips and forehead are all brighter than the stubble and eye sockets of the character (Fig.26).

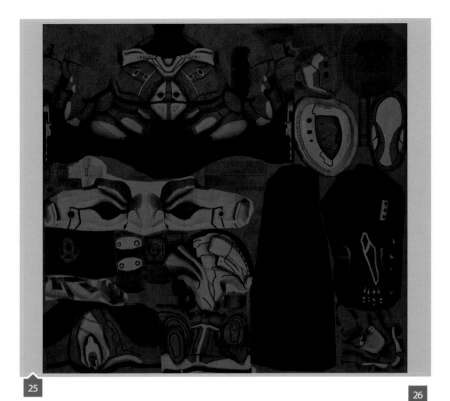

25

26

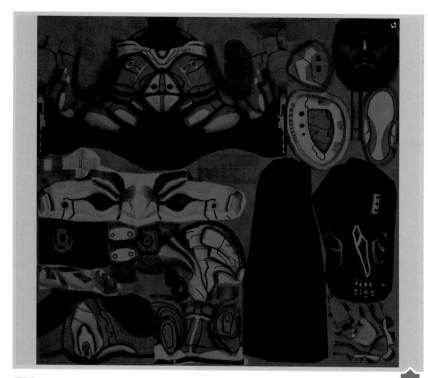

Step27

For the eye specular texture, generally you will have the entire eyeball darker with highlights over the iris to help mimic the sharp highlights that would appear in real life over the raised surface. You can also use a Reflection map in this case, but I find that (depending on the Reflection map, Cube map and lighting situation) the eye can become too busy (Fig.27).

Step28

To finish the Specular map, pump up the black division lines by multiplying the layer and manually painting in thicker lines where needed. Add in scratches and dings by painting in sharp highlights on the texture where wear and tear or battle damage may occur. Keep most of the scratches fairly subtle as you don't want that information to become too distracting considering that the character's armor is already fairly detailed (Fig.28).

Step29

Finally, to complete the set of character textures create an Emmisive map. This map consists of the lights you previously painted in with the color that will glow and nothing else. In the final render this texture will cause these areas to glow, but will not actually give off light (Fig.29).

Step30

After all of the textures are complete load them into 3ds Max using the Xoliul Shader for one last preview. At this stage I would move on to an actual game render for a more accurate representation of what the character would look like in a game, since the render in 3ds Max will be slightly different – this will be covered in the next chapter (Fig.30).

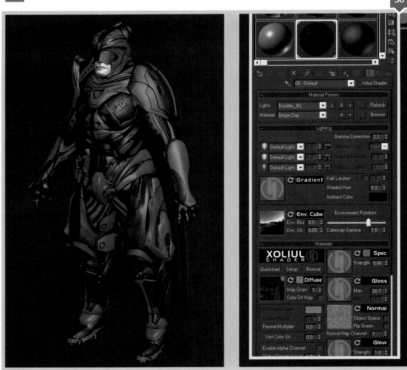

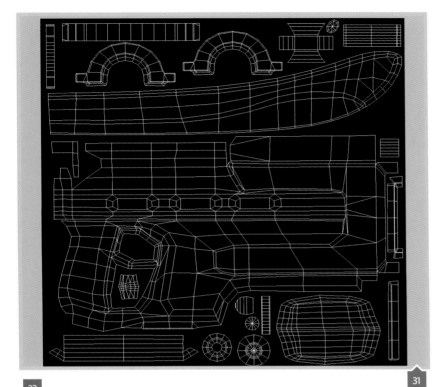

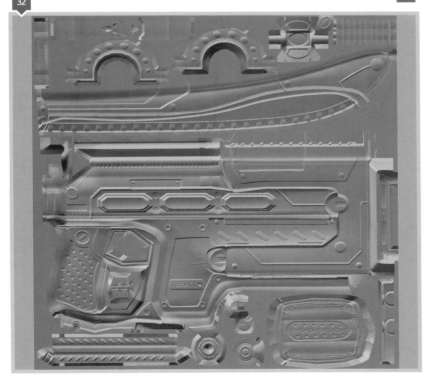

Step**31**

Next, move on to the weapons. Much like the beginning stages of the Swordmaster character himself, take the high resolution pieces and low resolution pieces, which all have mirrored UVs, and bring them into xNormal.

For the weapons you only need to do two render passes: one consisting of the main gun body, the sword blade and handle, and the other consisting of the gun's rails and sword hilt. This helps prevent rendering errors. Grab the UV map and use this as a guide, much like you did on the character textures (Fig.31).

Step**32**

In Fig.32 you can see that the Normal map bake is fairly clean. This is because I have moved the mirrored UVs off to the side of the 1:1 box, which means you can avoid issues where the UV seams will be. For the most part we are really just rendering information on one half of the gun and sword, but need the geometry of the other half to make the normals render properly. If the mirrored geometry/UV information was not there a hard edge would be created in the Normal map. Once the maps are baked, revert back to the old version of the model with overlapping UVs.

Step**33**

Much like the beginning stages of the character's diffuse Texture map, grab the weapon's Ambient Occlusion map and multiply it over the base metal color that is consistent with the character (Fig.33).

Step**34**

Next, preview how the bakes turned out using the Xoliul Shader in 3ds Max (Fig.34).

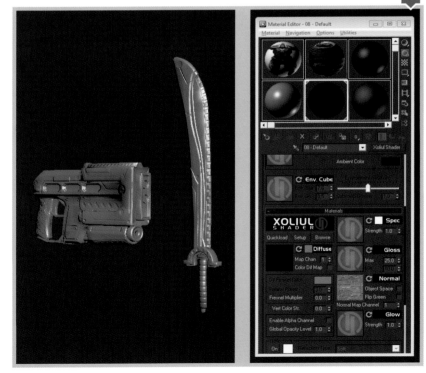

Step35

From here, grab the same colors used on the character and begin blocking out where the lighter metal areas will be on the weapons (Fig.35).

Step36

Finally pump up the contrast throughout the elements by painting in blacks between the metal plates, and filling in holes such as along the rails and the seams along the back of the sword. Also paint in some orange lights, much like on the character, to help give the gun a splash of color (Fig.36).

Step**37**

To begin the weapon's Specular map grab the Ambient Occlusion layer and drop it over a light gray background (Fig.37).

Step**38**

Further define the shading and line work created in the diffuse texture to separate the different mechanical and metal areas. At this point you can really see how much work the Specular map does, both on the character and the weapons, as the grunge map comes into play. The actual metallic surface is fairly clean and technically has no color change, but the Specular map will control how light is reflected off of the surface and this will really help sell the metallic look. Had we baked this information into the diffuse texture, the metal would appear more like concrete with flakes of black and white in the surface itself (Fig.38).

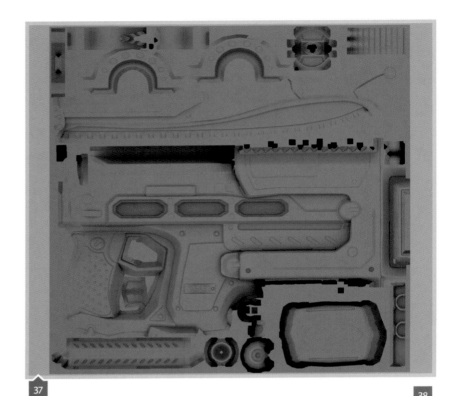
37

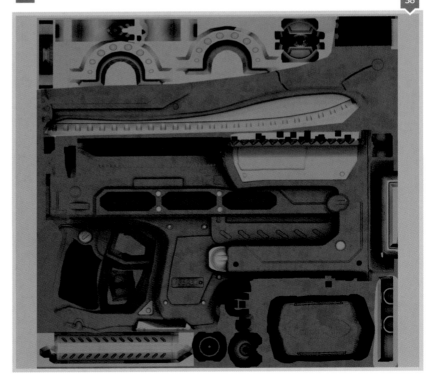
38

Step**39**

To finish off the weapon textures, grab the lights you previously painted and drop them on a black background to create our weapon's Emmissive map (Fig.39).

Step**40**

Finally, load all of the textures into 3ds Max and view the final result before posing the character model with accessories, and bringing it all into Marmoset for the final presentation shot (Fig.40).

Sidebar**Tip**: Texturing Shortcuts

When it comes to texturing your character, a lot of the leg work can be done for you by generating different types of maps to multiply or overlay on top of your Ambient Occlusion maps generated from xNormal. You could rip different channels out of your Normal map manually, by literally opening up the blue channel of the texture and using it as a Multiply layer on top of your diffuse texture. You could also use the xNormal Normal map Photoshop plugin to automatically generate Cavity maps based on your Normal map texture.

The most popular, and probably the quickest and most accurate method, is to use Crazy Bump. Crazy Bump is a very affordable program (with a fully functional trial edition if you would like to try before you buy) made specifically for creating Normal maps from photos and generating textures based off of Normal maps. Once you load a Normal map texture into Crazy Bump, you will be given a lot of different options that you can play with to get the desired effect. Normally, as part of my process, I will generate an Occlusion and Specularity map with enhance details, brightness and contrast boosted fairly high. This will generate very tight detail maps that you can then use as a Cavity Multiply layer for your diffuse texture or as a very solid foundation for a Spec map, and even as a Spec Fresnel map if your engine supports it.

CHAPTER**SIX**
PRESENTATION

Introduction

In this final chapter we will finish off the character model by covering some simple rigging techniques, including how to weight your character model to a skeleton. After this we will look into posing your character in both extreme and neutral action shots, and finally bringing it all together in Marmoset to create a final image for your online portfolio

Step**01**

Adding a pose to your character can really bring it to life. Dropping the character out of a static bind pose not only helps it to look more "finished" to the viewer, but it can also help sell what type of character it is by displaying emotion and attitude.

To begin, grab a clean version of the final low poly model. This means clearing off any materials that may have been on the character, double-checking that there are no floating vertices that may cause issues, and making sure that all of the elements of the model are properly merged together (discovering that a part of the model is not attached to the main element can be a stumbling block if left for too long) and none of the faces are flipped. I even go as far as exporting the model and importing it into a fresh scene. The

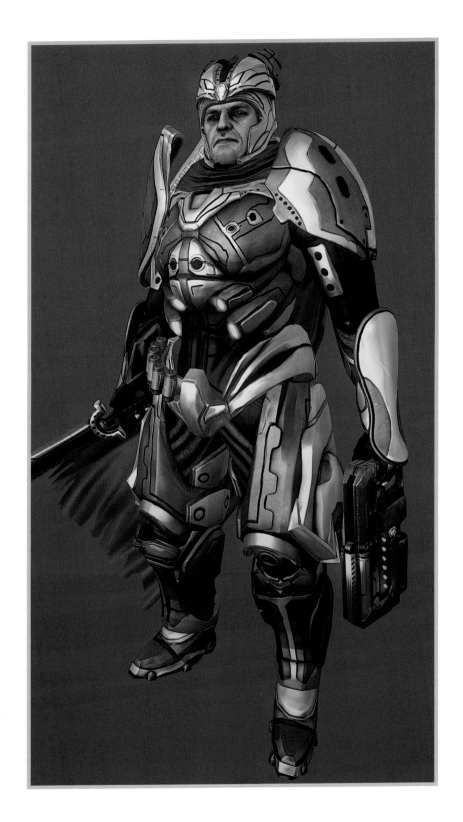

170

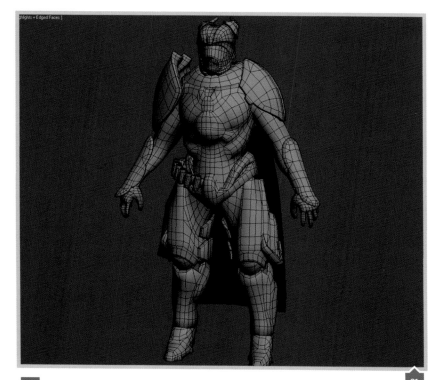

reason for this is that it is much easier to take these precautions before rigging than it is to discover that pieces of your model are missing or corrupted further down the line (Fig.01).

Step02

Essentially we will be creating a very primitive version of a human skeleton to deform our character model, much like real-world bones affect muscle and skin. The purpose of this skeleton will be to pose your character and render it off for your online or printed portfolio. Character rigging can be a very complicated discipline and many games have systems in place specifically for their needs or to meet engine requirements. So to just give an example, we will create a quick rig using the basic bone objects.

Enter an orthographic view like the front or the side to do the majority of your rigging. I find that working in perspective views can lead to a lot of errors, like bones being drawn in the distance and having incorrect rotations.

In 3ds Max, navigate to the Systems tab and select Bones. From here, in the front view, click where you would like the chain of bones to be and click where you would like the first bone to end, repeating the process until you get to the ankle. As you can see, you can then select bones and adjust their width or tapering effects (or, alternatively, enter these settings beforehand) (Fig.02).

Step03

Throughout the character we will basically be creating multiple chains with an effector at the end of each chain to control the movement. In a more complex rig, we could have controllers assigned to these locations for better visibility and constraint handling. For this example however, we will just create a small bone that will replicate the sockets in limbs like the ankle, wrist and neck.

Moving to the side view, grab the leg effector and give the entire chain a slight bend, as in real life the legs would not be perfectly vertical and making them so could lead to awkward deformations when bending them (Fig.03).

Step04

Next, while still in the side view, draw a chain from the leg effector to the toe. This chain will consist of a bone that will control the ankle/heel portion of the foot, as well as a bone for the toes. This chain will also have an effector bone at the end that will control the bending of the foot (Fig.04).

03

04

Step05

Switch to a different view – like front or perspective – to make sure the bones you just created are positioned within the mesh properly (Fig.05).

Step06

After this, move up to the pelvis and draw a chain from the center of the character to the top of the leg bone chain. This new chain, which will be half of our character's hips, and will consist of a pelvis bone and an effector, will have the ability to control the position of the buttocks and orientation (though limited) of the character's hips (Fig.06).

Step07

Once the legs and hips have been created, it's time to move on to the spine. Starting at the hips, draw a chain up to the neck through the center of the character. Obviously you won't create a bone for every bone in a real human's spine. I find that three or four spine bones make for good deformations throughout the character's torso (Fig.07).

Step08

Moving over to the side view, rotate the character's spine to fit the character's (and a human's in general) posture more realistically. The profile of a human generally forms a stretched out S shape, excluding extreme circumstances. Essentially this chain should consist of a bone for every major region of the character's torso, waist, rib cage and shoulders/chest, with an effector, in this case, to control the spine's twist and movement (Fig.08).

07

08

Step09

Move back to the front view and create a bone chain
for the arm. Starting at the shoulder socket, create
a bone to the elbow and then to the wrist, with an
effector to control the entire arm's movement. In some
cases it is wise to have two bones that create the
forearm to replicate the effects of the radius and ulna
on the human body. Since this character is mostly hard
surfaces with only limited movement, we don't need to
do this (Fig.09).

Step10

Moving back to side view, give the arm a slight bend to
match the character's pose. This will help the character
to deform more naturally in the end (Fig.10).

Step11

Next begin working on the hand bones. To simplify the area, create one bone to control the deformation of the palm and multiple chains for the fingers. Draw out a single bone for the palm and a three bone chain for one of the fingers. As you have most likely assumed, each bone in this chain represents a phalanx bone within the character's digits, with each bone ending approximately where the character's knuckles would be (Fig.11).

Step12

Once one finger bone chain has been created, select the entire chain and duplicate it. This should preserve the bone's hierarchy and loosely position each new chain at every finger and the thumb (Fig.12).

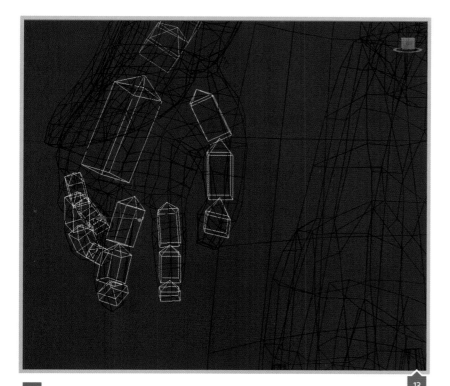

Step 13

Once all of the finger chains have been placed they will need to be adjusted to fit the character more accurately. Since our character model has a slight bend to his fingers, the finger bones will need to be bent to resemble this (Fig.13).

Step 14

After the hand bones have been placed, draw a two bone chain from the third spine bone that will make up the clavicle and the effector, which will eventually connect to the arms. Once this is completed you essentially have half of the character rigged. Since the Swordmaster model is predominantly symmetrical, we can grab all of the bones that make up the limbs, hips and clavicle, and mirror them in the front view (Fig.14).

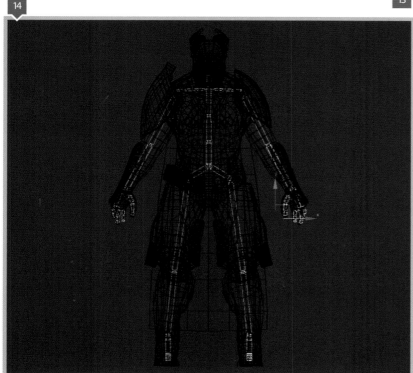

Step**15**

Next, moving on to the side view, create a single bone
for the head, the face and the jaw. In this example
I will not be rigging the face in depth. For a more
complicated rig there would be groups of bones
controlling various deformable parts of the face. In
this case the entire character head will be controlled
by one or two bones, with extra expression just being
modeled into the character's face by way of pushing
and pulling vertices (Fig.15).

Step**16**

After this, create a bone chain running from the
shoulder area to the tip of the cape, which will
control the deformation of that piece of fabric. For
smoother deformations here, add more bones than
the character's spine. Depending on the importance
and budget, some games will have multiple spines
controlling the cape, morph targets to control
billowing and even real-time cloth simulation.

All we really need, at least for portfolio renders, is some
slight deformation to get the starch out of the fabric
(Fig.16).

Step 17

Finally, add a single bone floating just above the upper arm bone to control the shoulder pads. Since these objects are completely solid I think it will be easier to have just one bone control them and nothing else, but have them follow the upper arm bone during movement (Fig.17).

Step 18

After hiding the character you will be able to see your character's skeleton in all of its glory. This is a good opportunity to check and make sure that you haven't missed anything before moving on to parenting and weighting (Fig.18).

Step**19**

Opening up the schematic view you can see that all
of our chains and floating bones are listed separately.
Much like a flow chart, a chain of bones is indicated by
boxes being attached with arrows, the last bone being
the final bone in the chain and the first bone being
the root of the chain. Selecting a limb will help give
a clearer vision of how the schematic view is laid out
(Fig.19).

Step**20**

For my characters, everything basically stems from
the pelvis, which means that the pelvis is the center of
gravity for my character.

Using the Linking tool (the chain icon in the top-left of
the screen and the schematic view window), first select
children bones and then link them to parents. Working
our way from the pelvis, the root of the right leg bone
would be a child of the hip effector and the root of the
foot bone would be a child of the leg effector at the
ankle. When all of this is linked it means that we should
be able to grab the leg effector and move it around
with the foot following in place, as well as being able
to grab the hip effector and move the entire leg as a
whole (Fig.20).

Step21

Moving on, parent all of the fingers to the palm, the palm to the arm effector, the arm to the clavicle effector and the clavicle root to the spine effector. Also parent the shoulder pad bones to the upper arm bones and the head bone to the spine effector.

To finish off the rig, create a dummy object, which can be another bone or an implicit object. This is essentially going to be culled out as no geometry will be weighted to it and, in some cases, will be ignored during an import to a game engine. Parent the root of the spine and the roots of both hip bones to this dummy object. So now you should be able to grab this object, move it around and have your entire character follow suit (Fig.21).

Step22

Now it is time to bind the character mesh to the skeleton that we have created. At this stage it may be wise to rename your bones so that they are easier to recognize, as "Bone32" can be confusing. Also, to make weighting easier you could split off parts of the model that will have no influence over the rest of the character, like the shoulder pads and the cape. These pieces will essentially be free-standing elements and because of the constraints we have set up, will already follow the character skeleton as a whole.

Apply a Skin modifier in the Bones panel and select the bones that you would like to influence your character (Fig.22).

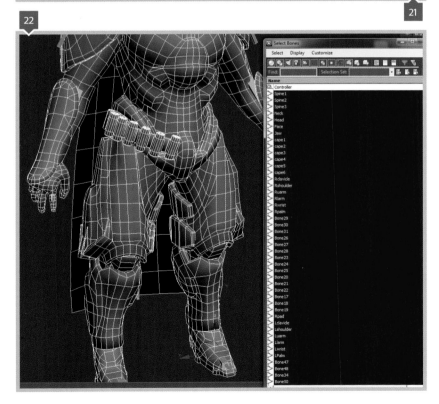

Step**23**

Navigate to Advanced Parameters > Bone Affect Limit and reduce the number of bones from 20 (the default) to something more reasonable, like 3 or 4. This means that three bones can influence a vertex at one time. Some consoles and engines will only allow a certain number of bones to control a vertex, so it is good practice to keep this number as low as possible. Also, the more bones that can influence an area of the model the more minor adjustments you might have to make. Sometimes it is better to have a crisper transition between one bone's influence and the other, like in the case of a forearm crashing into a bicep during deformations rather than having it bend smoothly (Fig.23).

Step**24**

To begin weighting, go through the character and rigidly weight areas to the bones they are closest to. Then move outwards and blend the influences from bone to bone. For the most part (as mentioned earlier) our character is fairly hard surfaced, with a limited range of movement that is more or less isolated to joints and the character's midsection. That being the case, it will be acceptable to have some elements being fully weighted to just one bone with no influence from others, such as the shin armor.

To edit the bone influences on your mesh, open up the Weight tool by clicking on the wrench icon. From here skinning is easy. Select the vertices you would like to edit (while in the Skin modifier), select which bone you would like to have influence them from the list and then enter a value. The Weight tool has quick buttons that allow you to add influence in quarters (which I usually stick to), but you can manually enter values as well (Fig.24).

Step 25

As mentioned before, a lot of the areas of our character can be rigidly weighted. For example, the upper leg armor of my character is fully weighted to the upper leg bone. For a smoother transition, grab the vertices near the character's crotch and add influence from the hip bone and hip effector. The knee area is blended between the upper leg and lower leg bones. The lower leg is full weighted to the lower leg bone and the character's boot is blended between the heel and toe bones (Fig.25 – 26).

Step**26**

Tackle weighting the character's torso by rigidly weighting chunks to the closest spine bone. The majority of the torso armor is devoted to the third spine bone, with the softer midsection being a blend between the first and second spine bones. The head and helmet are completely weighted to the head bone, with mild influence from the neck and jaw bone for the more organic parts.

As mentioned earlier, the shoulder pads are fully weighted to the upper arm bones, with the forearm armor being fully weighted to the forearm bone. For the softer, more organic parts, like the wrist and shoulders, I blend to the adjacent bone. The upper arm, for example, will blend into the clavicle and top spine bone (Fig.27 – 28).

27

28

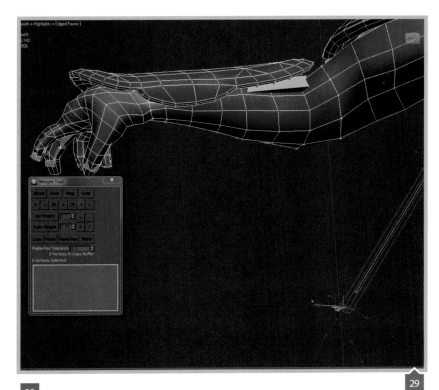

Step27

Moving down the arm, our character's wrist and elbow has a fairly even blend between the palm bone and upper arm bone. The character's fingers follow the closest bone fairly rigidly with blending at the knuckles (Fig.29 – 30).

Step**28**

Finally, pose your character. I find that by creating a few different poses you can test the limits of your weighting, which inevitably leads to tweaking the weights as needed to have the character looking its best in that particular pose.

For portfolio presentation it's a good idea to play it fairly safe for your character's pose and deliver a neutral shot. This will help avoid any awkward deformations that could mislead the viewer into thinking something is wrong with your actual model. For this example I've dropped the arms, relaxed the legs a bit, made the cape not so uniform, and twisted the spine and head to have the character looking at the camera (Fig.31).

Step**29**

After a few more tweaks, like adjusting the finger rotations and curl, pointing the toes to be more natural and removing the visor to show the character's face, you can bring in the Swordmaster's weapons for the final image (Fig.32).

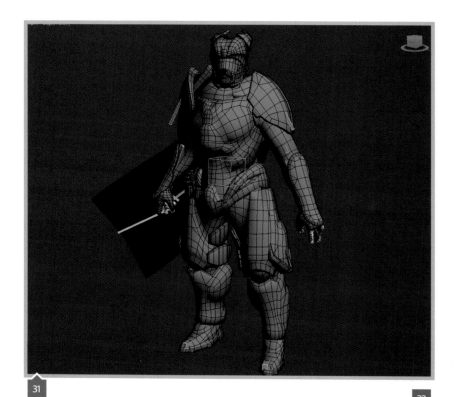

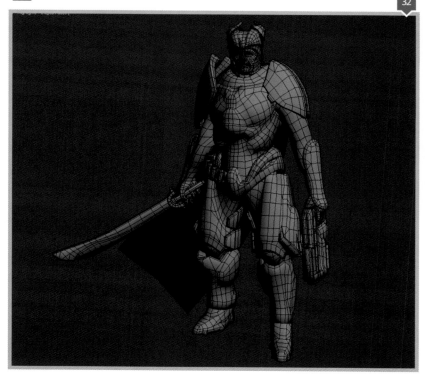

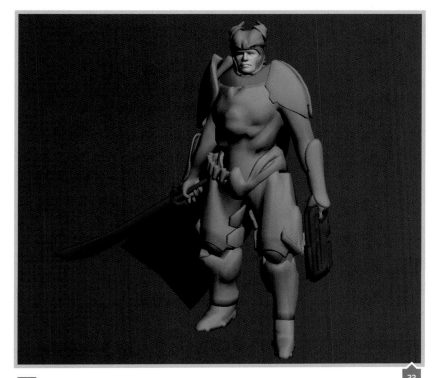

33

34

Step30

For the final presentation I suggest using the Marmoset Toolbag (http://www.8monkeylabs.com/toolbag). I like to use the Toolbag as a quick model viewer and rendering solution, due to its ease of use and focus on creating images for artistic presentation rather than full integration into a game engine. Many different features are available for post-processing effects, and exporting a print-ready image is as easy as pressing one button. It also accepts OBJ files and many different image formats without the need for a complex shader setup. For the most part, this tool just allows you to jump in and have a professional quality rendered image within a few minutes. Of course, you can also use the Xoliul viewport shader covered in a previous chapter as an alternative.

The Toolbag allows you to create multiple materials for your character using the same textures. Because there are a few different physical materials within the Swordmaster character, split off pieces of the model to reflect this. These pieces are: the face and eyes (which will use a skin shader), the character body (which will use a standard Phong material) and the weapons, which are a different texture set altogether.

Export all of the models together as one OBJ file. The different pieces will be recognized as chunks in the Toolbag (Fig.33).

Step31

Open up the Marmoset Toolbag and navigate to the File tab. Here you can open up a new mesh or, if you have a scene previously created, open that scene. Click on the Open Mesh button and select the Swordmaster model you just exported from 3ds Max (Fig.34).

Step**32**

The Toolbag automatically applies a default material on all of the models that are imported. So unlike other applications, material IDs and materials applied to the model during exporting have no effect. Creating materials is quick and easy and will basically involve creating a duplicate of the default material that you can then modify and save as your own. Simply click on New Mat, then set the name of the file and where you would like the materials to be saved. If you click on Save Mesh & Materials at any time it will save your model, materials and the material application to those models. To apply a material to your model, select the model (which will become outlined in white briefly) in the menu with a material selected and click Apply Selected Material. Once a material is active, it will be opened and closed by parenthesis.

I've created three different materials, as noted before, for the face, armor and weapons (Fig.35).

Step**33**

Next, in the dropdown Channel Model menu, there are multiple types of materials you can choose from. As mentioned before, I am going to choose a Phong material for the character's armor and weapons. This enables different texture slots, including the usual Diffuse, Normal and Spec, as well as some other options such as Emissive, which we will use for our glowing orange lights. Click on the name of the texture type and navigate to your texture map to load it into the Toolbag. Pressing C allows you to clear the field, R allows you to reload the texture and P brings up a map preview.

To see the single-sided cape, disable Backface Culling. For all of the materials in this example you will also want to enable Cast Shadows (Fig.36).

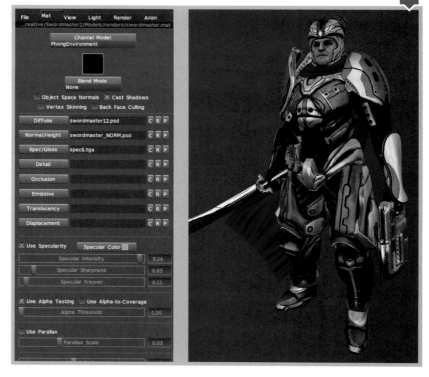

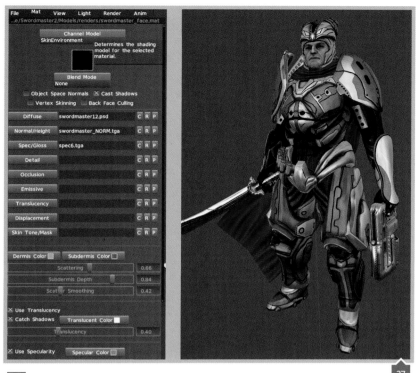

Step 34

Enter the textures for the Swordmaster's skin material and change the shader type to SkinEnvironment (Fig.37).

Step 35

Looking further down the list, you will notice that there are also different parameters that can be altered. In this case, I increase the specular power after enabling it and change the color to a lighter blue. This helps sell the polished steel look (Fig.38).

Step**36**

Navigation is fairly straightforward in the Toolbag.
Hold down Shift and use the mouse buttons to change
the orientation of the sky, which will function as the
scene's dominant light source. Hold down Alt and use
the mouse buttons to move the camera, and Ctrl with
mouse buttons to move your model.

An important thing to note is that your Normal maps
may be displayed inverted in the Toolbag viewport,
depending on the settings you entered during texture
baking. To fix this problem, navigate to the View
tab and click the Invert Y radio button, which will
essentially invert the green channel. To see this change,
you will need to click Apply (Fig.39).

Step**37**

Switching over to the Render tab, you will notice that
there are many different options for view modes. This
can come in handy if you want to show your posed
character with only one type of texture applied as a
material breakdown to viewers. For example, it can
be nice to show just the Diffuse, Normal and Specular
maps separately, and then the final composite (Fig.40).

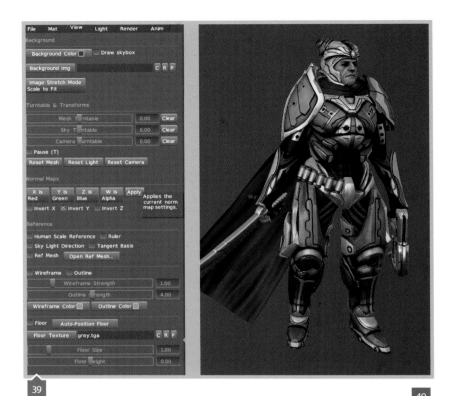

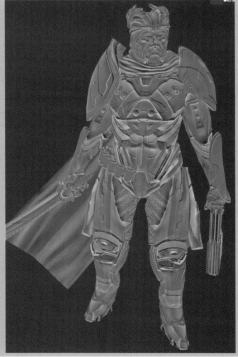

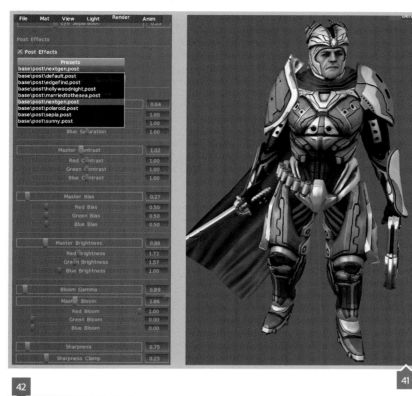

41

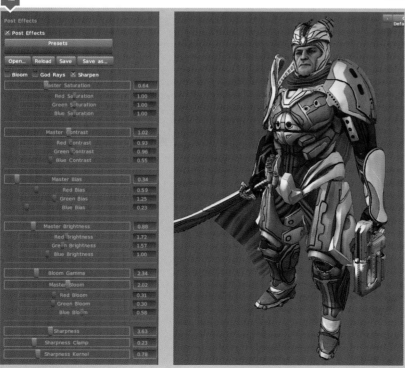

42

Step38

Scrolling further down the list in the Render section, you can enable and adjust post-processing effects. Generally, these are things such as Bloom or Sharpness. You can also adjust the brightness, contrast and color balance for your final image. The Toolbag has many different presets to choose from, ranging anywhere from your cliché brown, bloom-heavy Next Gen setting to less conventional, cinematic effects like Polaroid and Married to the Sea. You can play with these settings or create your own by adjusting the default settings. These post-processing effects can also be saved and loaded for other projects (Fig.41).

Step39

Select the Next Gen preset and begin tweaking the settings to better suit your needs. Generally update the sharpness of the image as well as some bloom values (Fig.42).

Step40

Finally, to export your image you can simply use Print Screen or, if you would like a higher resolution image that you can use for print or further alterations, navigate to the File tab again. Here you have the ability to adjust the image size by increasing the Enlargement value. Next, set your output folder and hit F12 to export an image. As a warning, depending on how strong your machine is, this function can fail if the image size is too large. So be sure to save your scene first (Fig.43).

Step41

Opening the screenshot you exported from the Toolbag in Photoshop, you can add color balancing layers for final tweaks to get your image exactly how you would like it. There really is no hard and fast rule here as every image can use different settings. Just feel free to play around with different adjustments until you are satisfied. I find that using the alpha channel exported with the image as a mask and applying Curves or Color Balance adjustment layers to pop out the highlights and shadows of the image really helps (Fig.44).

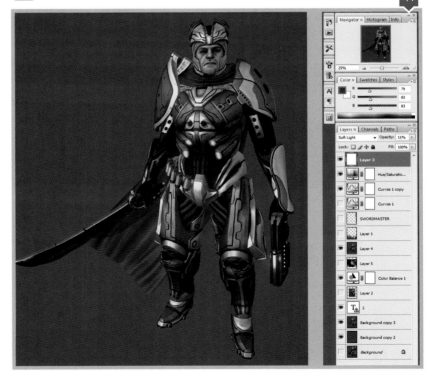

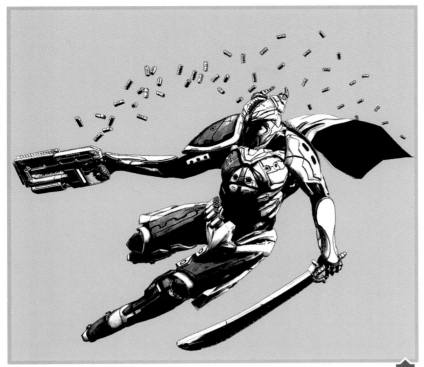

45

Step**42**

This is a perfectly fine place to stop! You have a great character with a presentation that shows the technical qualities of the model in a professional way with real-time rendering solutions. You can, however, move forward and create a beauty shot of your character as an addition that can use more external effects and a stronger action pose. I have created an action pose that has the Swordmaster character sailing into battle while firing off a few rounds at his opponent (Fig.45).

Step**43**

Here you can see the model using the same materials we had set up previously, with a different post-processing effect that pushes out the colder values in the image (Fig.46).

46

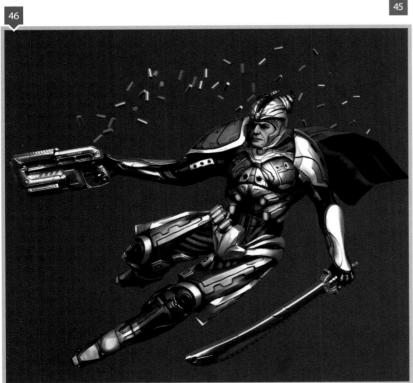

Step**44**

I've applied a red color wash in the post-processing settings, altered the Depth of Field settings to focus on the center of the character and slightly blurred out objects further away (e.g., bullets, tips of the cape, the right foot). I've also applied a vignette effect, which shades out the far corners of the image (Fig.47).

Step**45**

You can also play around with different lighting effects. For my dominant light source, which is based on the sky setting, I've chosen Sunlight. By enabling Show Skybox, this sky image will become visible. You can also add point lights, which I've used as accents, by clicking Add Light under the Dynamic Lights section. Once you create a light, you can alter its brightness and color as well as its position in the scene, which can be adjusted by interacting with the gizmo that appears over the light when its name is selected in the Lights list (Fig.48).

Step**46**

Again I've exported a screen shot (at 4x resolution, which is big enough for magazine prints). Bring this into Photoshop and add a gradient near the bottom of the image to help ground the character and adjust the color balance just a touch (Fig.49).

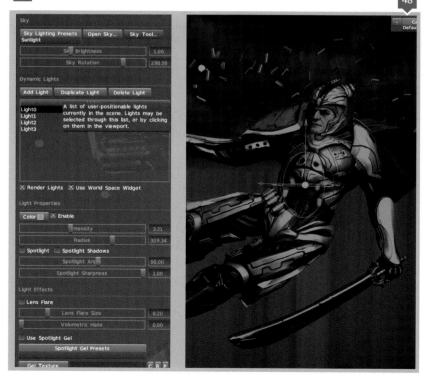

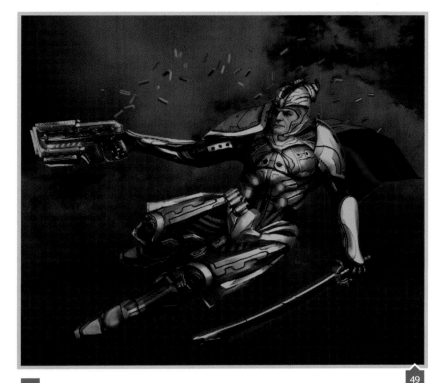

49

50

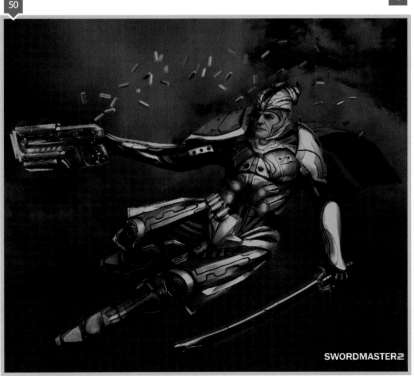

SWORDMASTER2

Step**47**

Here is where I've cheated a little and added a few minor effects like boosting up the glow of the armor lights and smoke to the gun. When I'm happy with everything, I add some descriptive text and save out the image and it's done! (Fig.50)

Sidebar**Tip**: Creating a Scene for your Characters

If you have the extra time, a great way to present a character is to place it in a scene similar to how you would see this asset in an actual video game. Often, competitions will require you to build a pedestal for your work for the same reason – it makes the final piece seem more complete. For the Swordmaster, I created a very simple, destroyed environment for my posed character to stand on. I also thought that it would be a great opportunity to add variation to the character to fill out his squad. Using poses from older renders, I simply took those elements and populated the scene with lesser characters, while still allowing the Swordmaster himself to be the focus point of the image.

After grabbing the dark sky background from Marmoset, I dropped it in behind the characters (rendering them off as separate elements to get more control of them individually), did a little bit of color correcting to tie the scene together and painted in some smoke effects to add atmosphere.

From the perspective of someone who reviews portfolios regularly, this is definitely more appealing. It shows more dedication, polish, attention to detail, and the ability to carry a project through to the very end. The only thing to keep in mind is that the character work is the point of interest; don't add elements that will take away from that and use methods that are comparable to a game engine environment. Happy rendering!

INDEX

ZBrush Character Sculpting V1

Projects, Tips & Techniques from the Masters

"Often you find a little information here or there about how an image was created, but rarely does someone take the time to really go into depth and show what they do, and more importantly why. This book contains clear illustrations and step-by-step breakdowns that bring to light the power of concepting directly in ZBrush, using it for full-on production work and using the software with other programs to achieve great new results."

Ian Joyner | Freelance Character Artist
http://www.ianjoyner.com

ZBrush has quickly become an integral part of the 3D modeling industry. *ZBrush Character Sculpting: Volume 1* explores the features and tools on offer in this ground-breaking software, as well as presenting complete projects and discussing how ZSpheres make a great starting point for modeling. Drawing on the traditional roots of classical sculpture, this book also investigates how these time-honored teachings can be successfully applied to the 3D medium to create jaw-dropping sculpts. Featuring the likes of **Rafael Grassetti**, **Michael Jensen** and **Cédric Seaut**, *ZBrush Character Sculpting: Volume 1* is brimming with in-depth tutorials that will benefit aspiring and veteran modelers alike.

This book is a priceless resource for:
- Newcomers to ZBrush and digital sculpting in general
- Artists looking to switch from a traditional medium
- Lecturers or students teaching/studying both traditional and digital modeling courses
- Hobbyists who want to learn useful tips and tricks from the best artists in the industry

Softback - 22.0 x 29.7 cm | 240 pages
ISBN: 978-0-9551530-8-2

Available from www.3dtotal.com/shop